IMAGES
of America

TAKOMA PARK

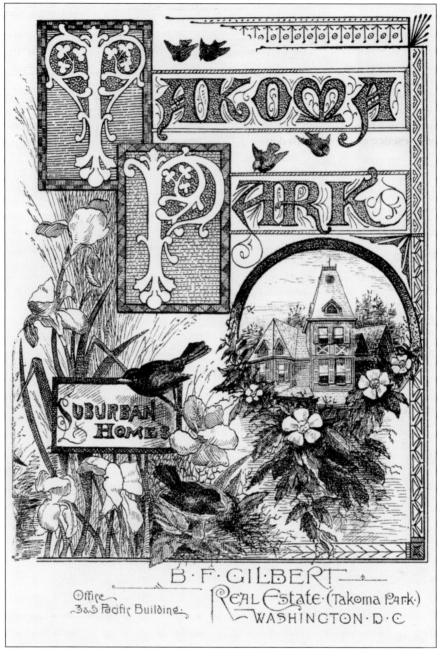

This artwork graced the cover of the 1888 marketing brochure created by Benjamin Franklin Gilbert to attract new residents to the sylvan suburb he founded on the railroad line north of Washington, DC. The house pictured here was Gilbert's own residence, lost to fire in 1915. Today, this graphic remains the iconic image of early Takoma. (Courtesy of Historic Takoma.)

ON THE COVER: Takoma Park's most enduring tradition is its annual Independence Day celebration. As this color guard float from the 1920s illustrates, children have played a prominent role in the parades since the early days. (Courtesy of Historic Takoma.)

IMAGES
of America

TAKOMA PARK

Historic Takoma, Inc.

ARCADIA
PUBLISHING

Published by Arcadia Publishing
Charleston, South Carolina

Printed in the United States of America

Library of Congress Control Number: 2010924654

For all general information, please contact Arcadia Publishing:
Telephone 843-853-2070
Fax 843-853-0044
E-mail sales@arcadiapublishing.com
For customer service and orders:
Toll-Free 1-888-313-2665

Visit us on the Internet at www.arcadiapublishing.com

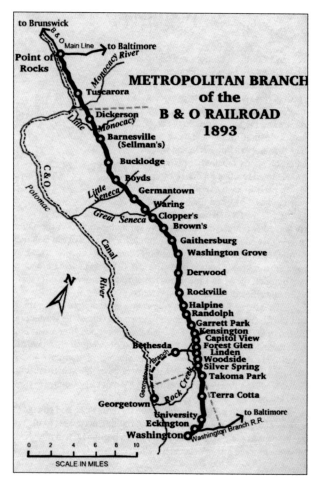

The 1873 opening of the Baltimore & Ohio Railroad Metropolitan line gave Gilbert an opportunity to create a new community where downtown workers could enjoy the benefits of country living. The new line stretched from the heart of Washington, DC, north to Point of Rocks near the West Virginia border. Gilbert chose the point where the railroad tracks crossed into Maryland as the site for Takoma Park. Many of the names on this 1893 station map are familiar as Metro stops today. (Map from *The Met: A History of the Metropolitan Branch of the B&O Railroad* by Susan Soderberg, published by the Germantown Historical Society.)

CONTENTS

Acknowledgments

This book celebrates B.F. Gilbert's vision and the many individuals who have sustained it over the years. We thankfully acknowledge the early historians and chroniclers whose legacies enrich this record: Dr. William Hooker, Charles Heaton, Frank Skinner, and John Coffman, as well as photographers Morris Bien and Arthur Colburn.

We are also grateful to the numerous archivists whose generous assistance enabled us to include material from important public and private collections, especially Faye Haskins (Washingtoniana Division of the Martin Luther King Library of the District of Columbia), Tim Poirier (Ellen G. White Estate Archives), Greg Gohlke (Review and Herald Publishing Association Archives), Lydia Parris (Washington Adventist Hospital), Lee Wisel (Washington Adventist University), Maureen Feely (Bliss Electrical School), Donna Guiffre (Montgomery Blair High School Archives), Angela Todd (Hunt Institute, Carnegie-Mellon University), Steve Whitney (Coolidge High School Alumni Association), and Richard Singer (Herald and Review Collection).

In addition, we salute the willingness of local residents to share their personal and family photographs, including Nancy Abbott-Young, Lois Chalmers, Karen Collins, Kay Daniels-Cohen, Dolly Davis, Cathy Fink and Marty Marxer, Robert Ginsberg, Tina Hudak, James Jarboe, Kathie Mack, Patricia Matthews, Chris Simpson, Jeanne Skinner, Saul Schniderman, and Bruce Williams. Eric Bond and Julie Wiatt of the *Takoma Voice* also deserve a special nod, along with David Lanar of Boy Scout Troop 33 and Jo Hoge of the Takoma Park Presbyterian Church.

We are especially indebted to the work of Ellen Marsh and Mary Ann O'Boyle, coauthors of the 1983 centennial history *Portrait of a Victorian Suburb*, and to archivists Karen Fishman and Ann Juneau for organizing the Historic Takoma collection.

This book has been a complicated project as we sought to gather photographs and to document previously untold stories and shed new light on old ones. We thank our Arcadia production team for their patience. We are grateful to Brian McGuire for his copyediting skills. Finally, we dedicate this effort, with esteem and affection, to Dorothy Thomson Barnes, Historic Takoma's resident historian, indispensable fact-checker, and on-the-scene observer since 1922.

—Diana Kohn, Caroline Alderson, and Susan P. Schreiber,
on behalf of Historic Takoma
info@historictakoma.org

INTRODUCTION

The land that became Takoma Park lies six miles north of the Washington Monument. Even after the Civil War, the capital city proper had not yet reached beyond Florida Avenue, and much of the woods and farmland to the north was still in the hands of the old colonial families who had established plantation-sized holdings.

When Confederate general Jubal Early advanced on Washington in July 1864, his troops marched through the future Takoma Park and adjacent Silver Spring (the compound of the Blair family). The two-day Battle of Fort Stevens, which just barely succeeded in deterring the Confederates from capturing the Union capital, was fought in the backyard of our future suburb.

The Union emerged from the war victorious, and in the heady days that followed, Washington continued the expansion begun in wartime. Speculators came to make quick money, artisans to work on large building projects, and young men were eager to fill government clerk posts. The Baltimore & Ohio Railroad Company opened the Metropolitan Line in 1873, linking the federal city with points north and setting the stage for the creation of suburbs like Takoma Park.

Developer Benjamin Franklin Gilbert was not the only one who saw the opportunity to create towns at the train stops, but he was the first to act on it. The land he purchased in 1883 lay on the boundary line between the District and Maryland.

A gifted promoter, Gilbert rapidly gathered energetic and forward-looking settlers ready to carve a community out of the woods. Within a year, there were five finished houses, and by 1888, there were 1,000 residents. By the time the town was incorporated in 1890, there was a prominent train station, a school, a church, and an Independence Day celebration on its way to becoming a tradition. Although only the Maryland side became the "town of Takoma Park," for the most part, the community ignored the boundary line as the town developed.

The optimism of the boom years was tempered by financial panics that constrained Gilbert's ambitions, but the town continued to attract new residents. Most notable were the Seventh-day Adventists, who arrived in 1904. Within a decade, the Adventist world headquarters, publishing house, hospital, and college were dominant features on the landscape, with Adventists constituting almost a third of Takoma Park's population. Among the residents were a small number of African American families whose occupancy predated Gilbert's subdivisions.

The addition of two trolley lines expanded the options for Takoma Park's early rail commuters. A healthy commercial district evolved around these connections and substantially survives to the present day. For a time, Takoma Park was the largest town in Montgomery County.

From its inception, B.F. Gilbert encouraged citizens to contribute and come together to address community issues. This can-do attitude fostered Takoma Park's political and social activism and also, perhaps, its reputation as one of the most vibrant and progressive communities in the area of metropolitan Washington, DC.

In the early decades of the 20th century, residents took an active hand in organizing their community life. An array of clubs appeared, including early scout troops, a volunteer fire department,

7

a library, and additional churches. As local young men marched off to World War II, residents opened their homes to an influx of wartime workers, such as nurses at Walter Reed Hospital, just across Georgia Avenue, and "government girls" who came to Washington to work in wartime government agencies. Residents planted victory gardens, kept watch for enemy planes, and installed blackout curtains.

Barely a decade later, successive waves of controversy rocked Takoma Park. When the State of Maryland proposed to route a 10-lane freeway through residential neighborhoods, sustained opposition by citizens not only averted the destruction of 200 houses, it helped shift the state's metropolitan transportation strategy from road changes to mass transit. Residents on both sides of the boundary line worked to protect the old houses and fight high-rise development by creating historic districts in the heart of the community. Takoma, DC, residents joined nearby District neighborhoods to establish Neighbors, Inc., with the goal of fostering racially integrated communities. Later, on the Maryland side, Takoma Park declared itself a sanctuary for Central American refugees, a nuclear-free zone, and a green city. On both sides, citizens gained a reputation for engagement and social action that remains a defining characteristic of the community as a whole.

As Takoma Park enters the 21st century, citizens still value the small-town atmosphere, tree-shaded streets and neighborhoods, and particularly a shared commitment to community life that links the past, present, and future.

One

CREATING A COMMUNITY
1883–1900

In the decades following the Civil War, the federal government and the capital city continued to grow. New communities grew up along the railroad lines radiating out of Washington, DC, to accommodate the expanded federal workforce. Though dependent on the employment and services of Washington, these suburbs were frontier developments, and their individual qualities would be determined, to a great extent, by the interests and involvement of their founders. For some, it was simply business. For Benjamin Franklin Gilbert, it was much more.

By 1883, Gilbert had gained confidence and maturity as an entrepreneur and real estate developer. He had operated the Temperance Dining Room downtown on F Street, NW, before turning his attention to building and selling houses in the city. At age 42, Gilbert was ready to embark on a grander effort, drawing on personal ideals as well as business acumen to fashion a new community that would be his focus for the remainder of his life. Searching for land that suited his vision as the setting for a stable, pastoral, family-focused community, he found it on the border between the District and Maryland. He had scouted well, as the 100-acre parcel provided natural springs and the Sligo Creek as a fresh water supply and forests with mature trees for shade and beauty. At 350 feet above sea level, Takoma Park promised relief from the heat and noxious smells of summer in urban DC. Property covenants prohibiting the sale and use of liquor would ensure against the intrusion of destabilizing and immoral elements. And trains provided an easy commute into the city.

Gilbert promoted this vision of a convenient and healthful refuge for government workers and their families with brochures showing already constructed picturesque cottages and narrative descriptions detailing all that a fully built and planted lot might hold. Even the street names embraced naturalistic imagery, with avenues named Oak, Maple, Holly, Cedar, Tulip, and Chestnut (becoming streets once they crossed into the District). Gilbert's lots were generous, with ample setbacks for gardens and elegant streetscapes embellished with shade trees and flowering shrubs.

Confirming his personal stake in the future of the new community, B.F. Gilbert moved his family into a grand house he had built at the corner of Tulip and Oak (now Cedar) Avenues. He encouraged the growth of political, religious, and social organizations and donated land for a nondenominational church and several parks. The incorporation of the town of Takoma Park in 1890 and Gilbert's election as the first mayor marked the solid anchoring of his vision.

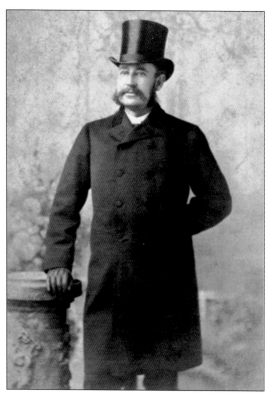

Born in New York State in 1841, Benjamin Franklin Gilbert embarked on his grand scheme for a sylvan suburb in 1883. He purchased 93 acres on the new railroad line 20 minutes north of the federal city and set about convincing friends and anyone who would listen to join him in the venture. Over the next two decades, he made 10 additional land purchases, greatly expanding the breadth of his vision. As a resident of the suburb, Gilbert could oversee expansion firsthand while taking advantage of the short commute downtown to promote the virtues of country living from his business office on F Street, NW, which is seen at right. He died in Takoma Park in 1907. (Both, courtesy of Historic Takoma.)

10

Carving a suburb out of woods and scrub farmland was a daunting task. This photograph, taken near the train crossing, shows the condition of the land when Gilbert bought it. He later told friends how his heart sank as he looked upon the newly acquired domain and realized what he had taken on and the work that lay before him. (Courtesy of Historic Takoma.)

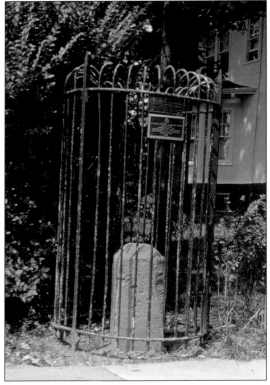

Gilbert's first purchase included this granite boundary stone, one of 40 markers set out between 1791 and 1792 to define the 10-mile-square District of Columbia. Recorded as NE No. 2, the Takoma Park boundary stone sits just north of the Carroll Avenue–Maple Street intersection. Aligned with the two nearby sections of Eastern Avenue, it marks the Maryland–District of Columbia dividing line. In 1916, the local chapter of the Daughters of the American Revolution installed a wrought iron fence to protect the boundary stone. (Courtesy of photographer Robert Ginsberg.)

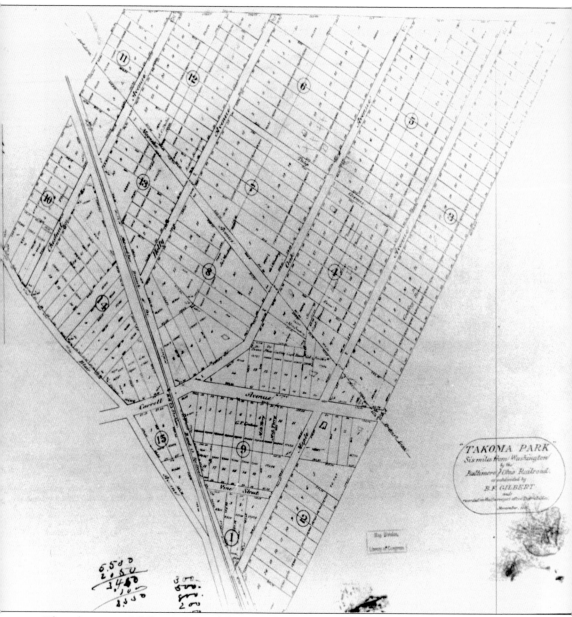

This plat map of Gilbert's first subdivision shows the layout of lots, which were a generous 50 feet wide by 200 feet deep. The Maryland–District of Columbia boundary is represented by the diagonal line across the middle, while the lower diagonal line indicates the Baltimore & Ohio Railroad. Note that several streets bear earlier names: Magnolia Avenue became Eastern Avenue, and Oak Avenue became Cedar. The first sale was to Amanda Thomas, whose residence still stands with its carriage house on part of the original nine lots along Tulip and Oak Avenues. (Courtesy of Historic Takoma.)

This c. 1886 advertisement is evidence that originally the town's name was spelled with a "c" before the post office required a change. Gilbert had adopted the suggestion of his friend Ida Summy to use an Indian word for a high, lofty place (the name translates literally as "snow-capped mountain"). When Gilbert took it upon himself to replace the original station sign of "Brightwood" with his new "Tacoma" sign, residents north of the station objected. (Courtesy of the Hooker Collection, Historic Takoma.)

The early spelling also appears in this depiction of the elegant turreted station from an 1886 *Washington Post* article. Designed by the Baltimore & Ohio Railroad's architect-in-chief E. Francis Baldwin, Takoma Park station stood on the southwest side of the railroad crossing. Morning exchanges among commuters evolved into the Takoma Park Citizens Association, the most influential champion of civic improvements for both sides of the boundary. (Courtesy of the Hooker Collection, Historic Takoma.)

TACOMA PARK,

The Most Desirable Spot for Residence in the Vicinity of Washington, and Destined to Become One of the Most Popular Resorts in the United States.

Sixty Fine Residences Already Erected!

ELEVEN HOUSES IN PROCESS OF CONSTRUCTION!

A School, with Fifty Pupils, in Successful Operation, and the Establishment of a Seminary for Advanced Pupils in Contemplation.

⋆ A Church to be Built in the Park ⋆

A Grand Hotel will be ready for Occupancy, in all Probability, by June 1, 1888.

Of all the suburbs of Washington, none is lovelier in its Natural Scenery, none more Healthful, none more accessible.

Malaria is Unknown,

And Malarial Patients Visiting the Park are Speedily Cured.

Takoma Park is but six miles from the Capitol, and may be reached (in ten minutes by express) via trains on Metropolitan Branch of the B. and O. Railroad, there being 19 trains daily, and Sunday church trains, day and evening, as per the following schedule:

WEEK DAYS:
Trains leave Washington for Takoma at 6:35, 8:40, 9:30 a. m., 12:30, 4:10, 5:30 (express), 5:35, 7, 11:20 p. m.
Trains leave Takoma for Washington at 7:20, 7:43, 7:58, 8:08, 9:21, 11:07 a. m., 2:38, 3:38, 4:52, 7:13, 8:09, p. m.

SUNDAYS:
Trains leave for Takoma, 8:40 a. m., 1:10, 5:33, 10 p. m.
Trains leave for Washington, 7:43, 8:08, 10:02 a. m., 4:52, 8:00 p. m.

The drives to Takoma Park are the finest out of the city, and the Park is the objective point of most of those desiring to see the most beautiful surroundings of Washington. The streets and roads are graded and graveled, a force of men being constantly at work keeping the grounds in order. It is noteworthy that while there is a lull in the demand for property in other suburban subdivisions, interest in Takoma Park has steadily increased, as is evidenced in the fact that purchases for residence have continued uninterruptedly. The resident population is made up from among the very best citizens of the District. Included in the list of purchasers of lots are ladies and gentlemen who buy and build for occupancy, rather than for speculative purposes. Among those who have purchased lots in Takoma Park are the following, many of whom have already

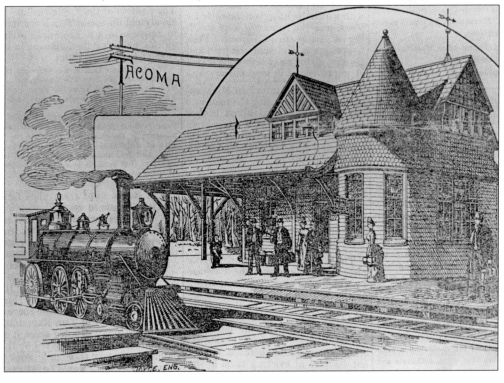

13

Early on, Gilbert recruited Frederick and Lewis Dudley as builders-in-residence. The Dudley brothers constructed many of the early homes, including the Thomas house, the Cady-Lee mansion, and Gilbert's own residence. Frederick built a home for his own family at the corner of Willow and Carroll Streets, and there, on September 29, 1885, his wife, Cora, gave birth to William Wentworth Dudley, the first child to be born in Takoma Park. (Courtesy of Historic Takoma.)

In 1886, Gilbert began selling lots in New Takoma, a second subdivision across Carroll Avenue extending east to Elm Avenue. Among the new residents were amateur photographers Arthur Colburn and Morris Bien, each of whom left a priceless record of the emerging suburb. Colburn captured this image of his sister Helen outside their home on Carroll Avenue, just north of the intersection at current-day Westmoreland Avenue. (Courtesy of the Colburn Collection, Historic Takoma.)

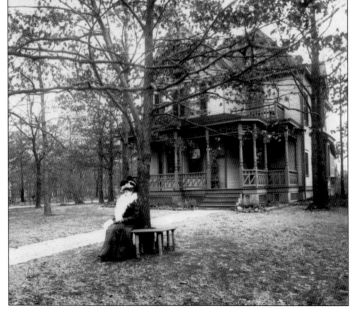

Morris Bien took this photograph of his wife, Lilla, in their Montgomery Avenue home with an early-edition Brownie camera (hence the circle frame). Among his other favorite subjects were his children and their friends, often captured enjoying their many games and outdoor activities. (Courtesy of the Bien Collection, Historic Takoma.)

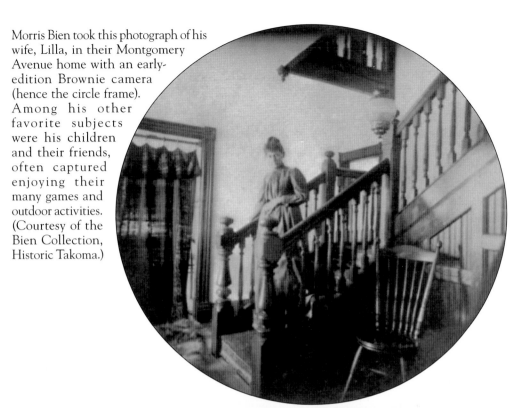

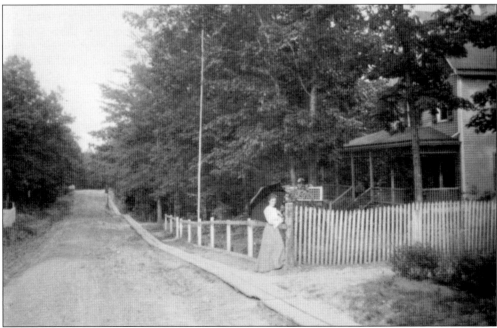

This Bien image of Ethel Mooers, a Montgomery Avenue neighbor, conveys the rural quality of early Takoma Park. Most of the streets remained dusty paths until after 1900, when the citizens' association mounted a concerted campaign to pave local streets, a project which took several decades to complete. (Courtesy of the Bien Collection, Historic Takoma.)

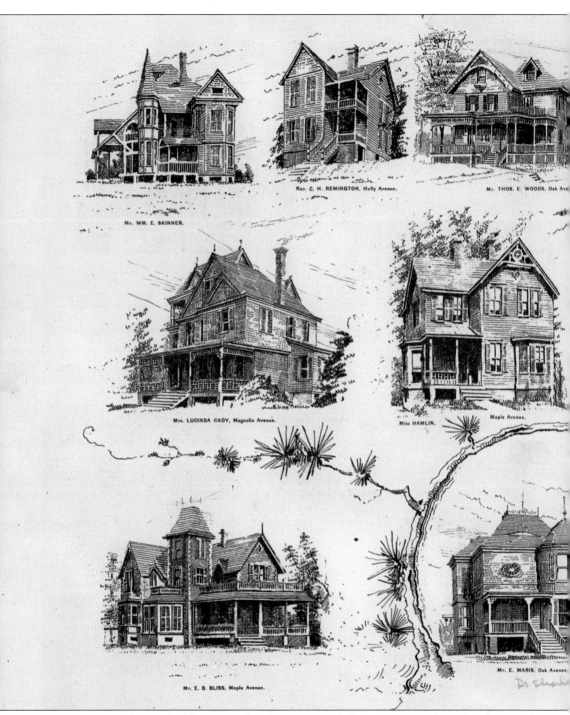

Mr. WM. E. SKINNER.

Rev. C. H. REMINGTON, Holly Avenue.

Mr. THOS. E. WOODS, Oak Ave

Mrs. LUCINDA CADY, Magnolia Avenue.

Miss HAMLIN, Maple Avenue.

Mr. E. B. BLISS, Maple Avenue.

Mr. E. MARIS, Oak Avenue.

By 1888, seventy houses had been completed, prompting Gilbert to create a fancy brochure with pen-and-ink drawings advertising the sylvan nature of his suburb in hopes of enticing new residents. Dr. Robert McMurdy helped write the flowery text extolling the affordable and picturesque nature of the community: "The elegance and comfortable appearance of the villas and cottages call forth the admiration of all who see them . . . yet the cost of each dwelling is quite moderate." Aimed at

16

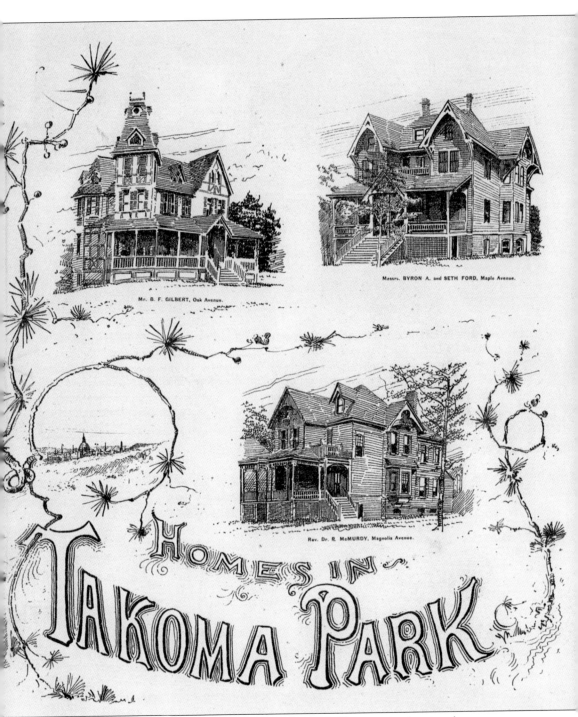

Mr. B. F. GILBERT, Oak Avenue.

Messrs. BYRON A. and SETH FORD, Maple Avenue.

Rev. Dr. R. McMURDY, Magnolia Avenue.

HOMES IN TAKOMA PARK

the federal clerks and their families living in overcrowded housing in the city, the text goes on, "See if the amount you must pay out for rent would not soon give you a home of your own in this delightful suburb." Most of the houses on this centerfold still stand today, one exception being Gilbert's own home (top, second from right). (Courtesy of Historic Takoma.)

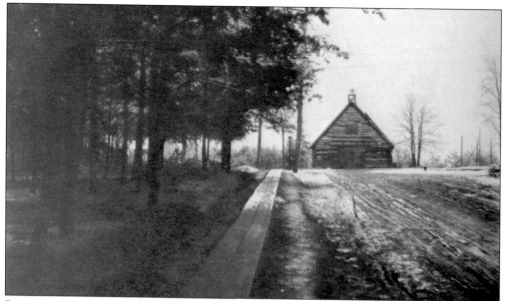

Benjamin Harrison's use of the log cabin as the symbol for his 1888 presidential campaign prompted many communities to erect their own rustic buildings. Gilbert built this log cabin on Carroll Avenue, across the Maryland line and four blocks east of the commercial area around the railroad station. The cabin served as a rallying point for the Republican Party and became a favorite community gathering spot, especially for Fourth of July celebrations. (Courtesy of the Colburn Collection, Historic Takoma.)

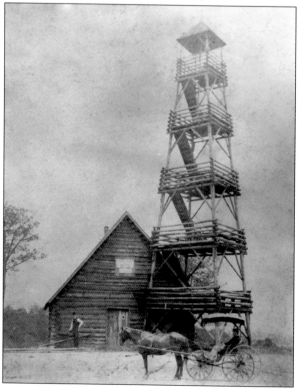

In 1889, Gilbert added a six-story tower and invited prospective customers to survey the available land from above in order to choose their own lots. The tower collapsed in 1905, but the cabin continued in service, first as the fire station, then a jail, before burning down in 1915. Storefronts did not appear on this stretch of Carroll Avenue until 1922, when the trolley turnaround encouraged its development as a second commercial center, this one on the Maryland side. (Courtesy of Historic Takoma.)

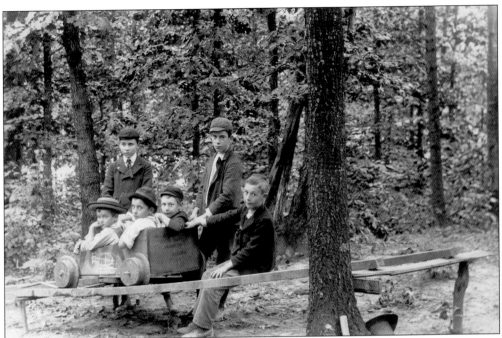

Young boys enjoyed constructing all manner of simple vehicles and gadgets. These six ingenious friends on Elm Avenue figured out how to build their own roller coaster. From left to right are (seated) T.H. Bien, Morris Phillips, Deming Shear, and Sherwood Shear; (standing) Sidney Bursley and Hallie Mooers. (Courtesy of the Bien Collection, Historic Takoma.)

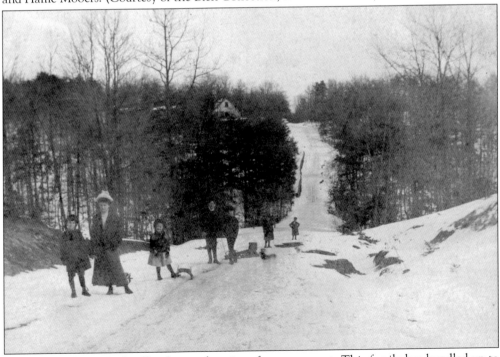

Winter in Takoma Park offered several options for amusement. This family has bundled up to take advantage of the downhill slope of Elm Avenue. (Courtesy of Historic Takoma.)

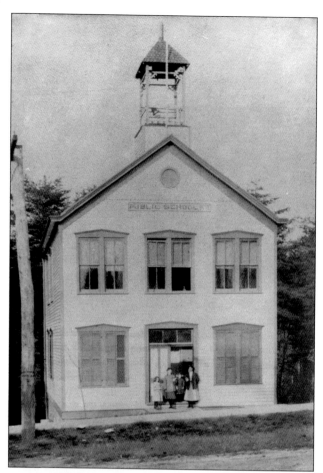

By 1888, twenty-nine children were attending school in a local home. The formal request to the county seat in Rockville for funds to construct a school was turned down, although the county agreed to provide building materials. Gilbert donated land on Tulip Avenue just east of Maple Avenue, and residents themselves built the four-room schoolhouse, Public School No. 8. Classes were held here until 1923. (Courtesy of Historic Takoma.)

In 1889, residents tired of having to travel into Washington for church on Sundays pledged $1 monthly payments to a church-building fund. Constructed on Maple Avenue at Tulip Avenue, near the school, Union Chapel was nondenominational. Religious services rotated among pastors of different affiliations until the Presbyterians took over the building in 1893. (Courtesy of the Bien Collection, Historic Takoma.)

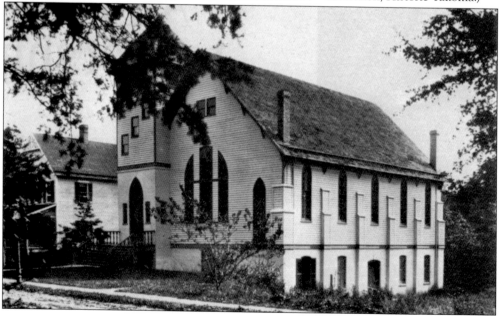

As a result of intense lobbying by Takoma Park residents, the Maryland legislature passed a resolution allowing the village to incorporate and establish an elected government in April 1890. There was one catch: only the area geographically located in Maryland qualified. As the first election ballot shows, Gilbert became mayor, to no one's surprise, serving with five council members. Meanwhile, Takoma residents on both sides of the boundary continued to function as one community. (Courtesy of Historic Takoma.)

The opening of the Brightwood Electric Railway in 1893 stimulated commercial development along Fourth Street next to the train station. Mothers and children preferred the trolley for trips into downtown Washington, often heading for the huge Central Market, where the National Archives now stands. By 1898, a second trolley line extended to Sligo Creek. (Courtesy of Historic Takoma.)

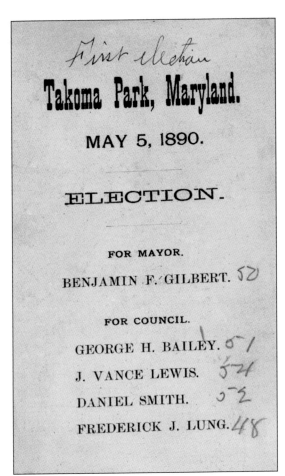

First election

Takoma Park, Maryland.

MAY 5, 1890.

ELECTION.

FOR MAYOR.

BENJAMIN F. GILBERT.

FOR COUNCIL.

GEORGE H. BAILEY.

J. VANCE LEWIS.

DANIEL SMITH.

FREDERICK J. LUNG.

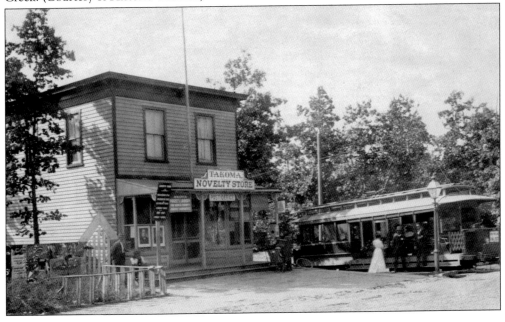

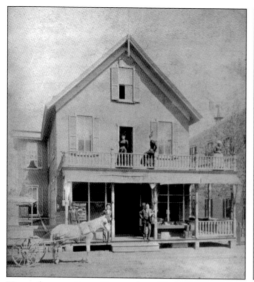

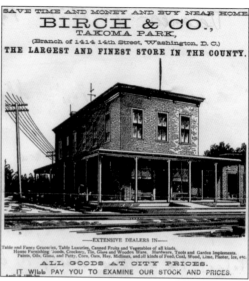

Tragedy struck on December 29, 1893, when fire swept through the small business district on the east side of the railroad tracks (near today's Metro entrance). Three commercial buildings burned to the ground, including Favorite's General Store (top left), which had been the town's first store when Isaac Thomas opened it in 1884. Although rebuilt two blocks east, the new Favorite's lost its status as home to the first post office and the only telephone in town. Birch & Co. (top right), with its second-floor assembly hall, never reopened, nor did the 30-room Watkins Hotel (bottom), although William Watkins later built an apartment building at Cedar and Fourth Streets for his six daughters. (All, courtesy of Historic Takoma.)

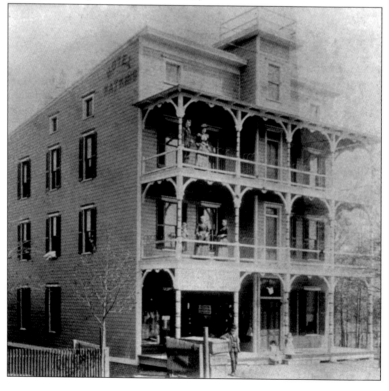

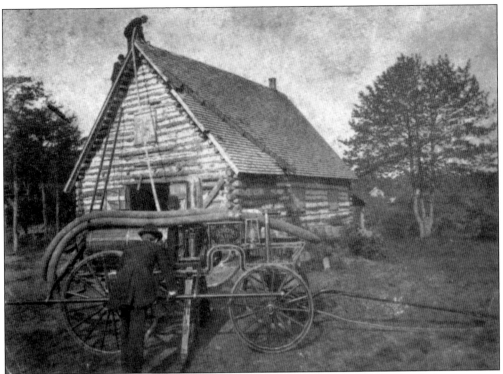

Even before the merchants rallied to replace the lost buildings, George Favorite headed a committee to organize a volunteer fire department. They purchased a pumper (above), which was stored in the cabin at Carroll and Laurel Avenues. Favorite was named fire chief but found time to rebuild his general store on Carroll Avenue near Maple Street. (Courtesy of Historic Takoma.)

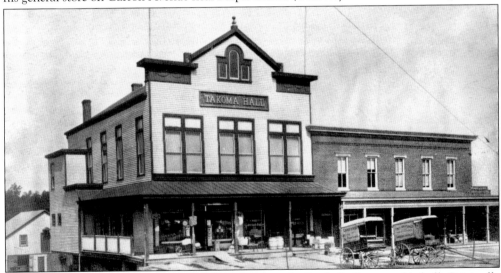

Takoma Hall rose from the ashes of the fire to replace the Birch & Co. assembly hall. Originally erected by the Masonic lodge, Takoma Hall's many functions included serving as the first sanctuary of the Seventh-day Adventists and briefly as home to Bliss Electrical School, before housing several retail enterprises. The building stood until the late 1970s, when it was removed to make way for the Metro. (Courtesy of Historic Takoma.)

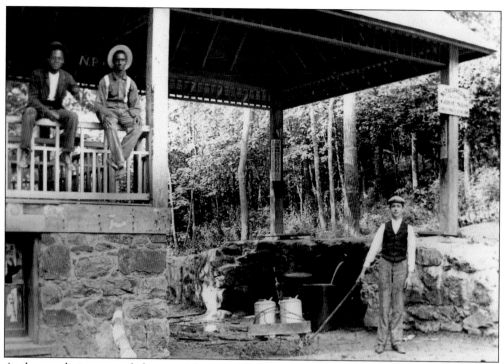

As the population expanded, water rights created controversy. This springhouse sat over Big Spring on Elm Avenue, the most impressive of the many springs in the new suburb. Gilbert bottled this water and sold it locally under the Takoma Park Springs label, claiming it was purer than Poland Spring water, the leading competitor of the era. Many residents fetched water directly from Big Spring until Gilbert took steps to restrict public access in 1891. The community took him to court, and Gilbert was forced to reopen the spring for public use. Local residents continued to collect water there until the city declared it too contaminated in 1942 and capped it permanently. (Both, courtesy of Historic Takoma.)

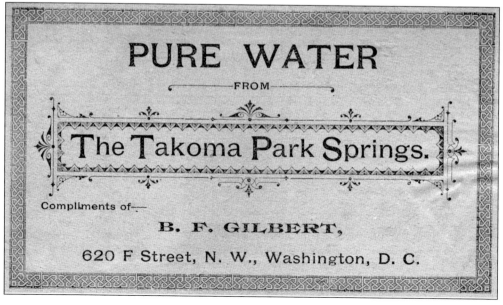

PURE WATER
—FROM—
The Takoma Park Springs.
Compliments of—
B. F. GILBERT,
620 F Street, N. W., Washington, D. C.

By 1898, springs and wells could no longer supply enough water for the town's needs. A water committee, seen here, oversaw the construction of a dam and water filtration plant on Sligo Creek. A 140-foot water tower capable of holding 50,000 gallons was erected on Ethan Allen Avenue, across from General Carroll's estate, and quickly became a town landmark. (Courtesy of Historic Takoma.)

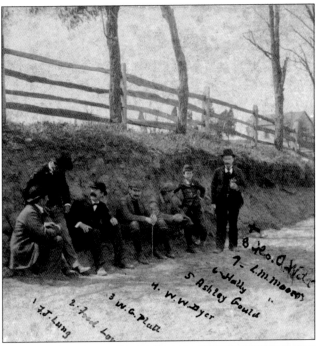

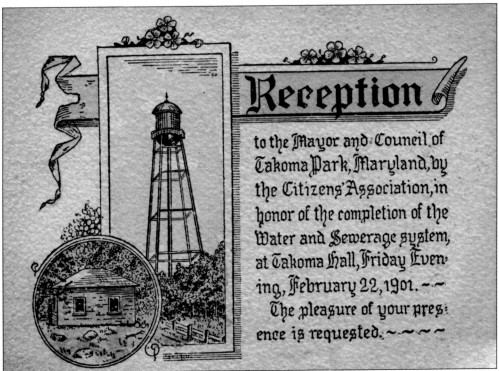

The water began flowing on Thanksgiving Day, November 29, 1900. The following February, the whole town turned out for a formal reception sponsored by the citizens' association. The new water system remained in use until Takoma Park switched to the county water supply in 1919. The tower was subsequently torn down. (Courtesy of Historic Takoma.)

Gilbert was able to expand his holdings yet again when Gen. Samuel Sprigg Carroll died in 1893. A Union hero at Gettysburg, the general retired to his family lands two decades before Gilbert's arrival. What is now Carroll Avenue ran from the train station to his house and was the only preexisting road in the suburb. Carroll's daughter agreed to sell to Gilbert on the condition that the streets in the new subdivision would be named after Civil War generals. Carroll's house (below) deteriorated until it was finally burned down as part of a fire department training exercise in 1961. An apartment building now occupies the site on Manor Circle near Ethan Allen Avenue. (Left, courtesy of Prints and Photographs Division, Library of Congress; below, courtesy of Washington Adventist University.)

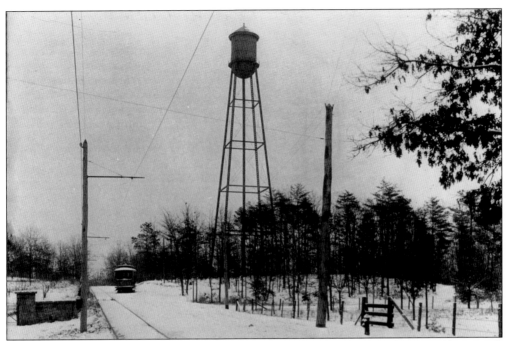

In 1898, the Baltimore & Washington Transit Trolley Line from Old Takoma to Sligo Creek a mile away provided new recreation options. Passengers headed up Carroll Avenue then onto Ethan Allen Avenue (past the water tower) before turning left for a steep downhill run through the woods to Sligo Creek. In 1901, Asa Wiswell opened Wildwood on the site of old Sligo Mill at what is now the bottom of Heather Avenue. (Courtesy of Historic Takoma.)

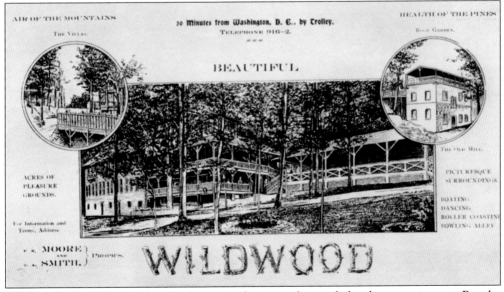

Wildwood offered boat rides and a dance pavilion complete with family entertainment. But the ambitious scheme failed. The resort ended operation in 1903 and was sold to a syndicate of Baltimore investors. The property ended its days as a scandalous gambling salon, closed permanently in 1905 after a Wild West–style raid by the local sheriff. Unlike the similar complex at Glen Echo Park, no trace of its glory days remains. (Courtesy of Historic Takoma.)

From the beginning, Sligo Creek was a favorite haunt for residents. Sligo Creek's name dates to 1811, when three Carroll family members purchased 414 acres to construct a mill where the creek now crosses New Hampshire Avenue. By 1900, a bridge for vehicles replaced wooden footbridges, and Carroll Avenue was rerouted over higher ground. (Courtesy of Historic Takoma.)

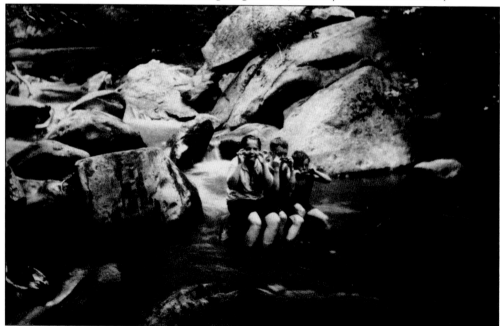

Separated from the early residential streets by woodlands, Sligo Creek beckoned to young and old. Morris Bien's camera captured three boys cooling off on one of the hot, lazy days of summer. Ice skaters appeared when winter turned the creek into a frozen wonderland. A hundred years later, most rainfall is diverted into storm sewers, lowering water levels, and Sligo Creek serves instead as a backdrop for hikers and bikers. (Courtesy of Historic Takoma.)

Two

WELCOMING THE
ADVENTISTS
1900–1910

In 1903, representatives of the Seventh-day Adventist Church approached Takoma developer B.F. Gilbert, now slowed by a stroke, with an intriguing proposal. They were seeking to relocate from their world headquarters in Battle Creek, Michigan.

One of most successful sects to emerge from the religious revivals of the 1840s, the Adventists organized their church around Saturday worship, preparing for the return of Christ (the advent), and an obligation to keep the body healthy to honor God. Embracing progressive ideas about healthy living that were decades ahead of their time, the Adventists shunned alcohol, meat, tobacco, and caffeine.

When fire destroyed their publishing house and hospital in Michigan, Adventist leaders took it as a sign that God desired them to move elsewhere. Their search led to Takoma Park, with its abundant fresh water and appealing natural beauty. Land at the south end of town provided the benefits of a DC address for their headquarters, and a piece of cleared land on the banks of Sligo Creek to the north was an ideal site for a hospital and college. Alcohol was even banned here, as part of Gilbert's long-standing commitment to temperance. Ellen White, their spiritual leader, declared that God had paved the way.

Gilbert welcomed the Adventists, especially their plan to build a hospital, which had been part of his vision for the community all along.

Many of the faithful left Battle Creek for Takoma Park, and over the next five years, the Adventist Church constructed its world headquarters and publishing facility at Eastern Avenue and Laurel Street in the District, while the college and sanitarium rose on the banks of Sligo Creek. Modeled after the sanitarium developed in Battle Creek by Dr. John Harvey Kellogg (coinventor of Kellogg's Corn Flakes), treatment emphasized fresh air, exercise, hygiene, and a vegetarian diet.

Over the next several decades, these institutions were collectively the largest local employer, and Adventists represented as many as one-third of the residents.

The Adventist move to Takoma Park marked the final legacy of B.F. Gilbert, who died in 1907.

Ellen White was part of the original group that evolved into the Adventist Church. When she began experiencing visions, the church accepted them as direct messages from God, and they became a guiding force of the faith. Her visions defined Adventist beliefs, the church's mission, emphasis on health, and even the decision to leave Battle Creek to establish a new headquarters. (Courtesy of the Ellen G. White Estate Archives.)

GROVE MEETING

On Sanitarium Grounds on the Banks of the Sligo

✤ AT TAKOMA PARK ✤

Sunday, August 7, 1904

A meeting for the purpose of setting before the public the Objects and Aims of the Institutions now being established by the Seventh-day Adventists at Takoma Park.

... PROGRAM ...

Forenoon Addresses, Commencing at 10 O'clock

The Washington Training College	W. T. Bland
How We Build	W. C. White
Objects and Aims of the Washington Sanitarium Association	G. A. Hare, M. D.
Relation Between Health and Christian Living	G. B. Thompson

Afternoon Addresses, Commencing at 3 O'clock

The Removal of Our Headquarters	J. S. Washburn
Education in the School and the Home	Mrs. E. G. White

You are cordially invited to attend.
Come in the morning, bring lunch, and stay all day.
Good singing, with orchestral accompaniment; also solos, and male quartet.

In 1904, the entire leadership of the Seventh-day Adventist Church gathered in Takoma Park for its annual grove meeting. Participants debated church policy and learned of the plans for their new home. Ellen White was among those who addressed the crowd assembled in tents pitched on the grounds of the future college. (Courtesy of Washington Adventist University.)

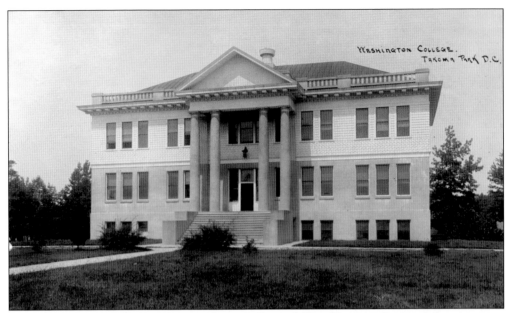

After the gathering, White took up residence in General Carroll's manor house while supervising construction of the college. Together, students and faculty built North Hall—part dorm, part classrooms—and the Foreign Mission College officially opened in the fall of 1904. College Hall, seen above, was finished a year later and still stands, currently serving as the science building. (Courtesy of Washington Adventist University.)

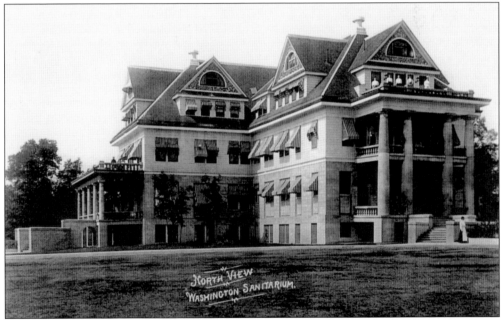

Once the college was established, the focus turned to building the Washington Sanitarium on the other half of the 48-acre parcel. Presenting a much more imposing facade, the "San" opened on June 13, 1907, with 40 patients and a staff of 12. Profits from Ellen White's book sales allowed this first medical facility in Montgomery County to open debt-free. (Courtesy of Washington Adventist Hospital.)

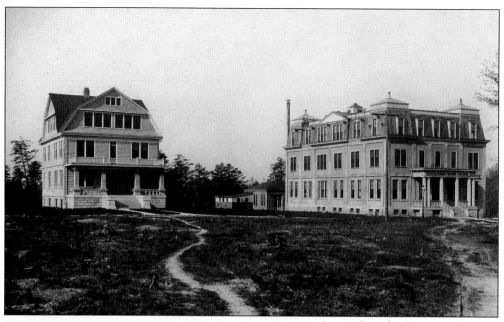

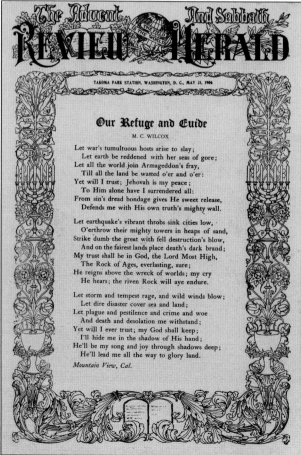

The Advent And Sabbath REVIEW HERALD

TAKOMA PARK STATION, WASHINGTON, D. C., MAY 31, 1906

Our Refuge and Guide

M. C. WILCOX

Let war's tumultuous hosts arise to slay;
 Let earth be reddened with her seas of gore;
Let all the world join Armageddon's fray,
 Till all the land be wasted o'er and o'er:
Yet will I trust; Jehovah is my peace;
 To Him alone have I surrendered all:
From sin's dread bondage gives He sweet release,
 Defends me with His own truth's mighty wall.

Let earthquake's vibrant throbs sink cities low,
 O'erthrow their mighty towers in heaps of sand,
Strike dumb the great with fell destruction's blow,
 And on the fairest lands place death's dark brand;
My trust shall be in God, the Lord Most High,
 The Rock of Ages, everlasting, sure;
He reigns above the wreck of worlds; my cry
 He hears; the riven Rock will aye endure.

Let storm and tempest rage, and wild winds blow;
 Let dire disaster cover sea and land;
Let plague and pestilence and crime and woe
 And death and desolation me withstand;
Yet will I ever trust; my God shall keep;
 I'll hide me in the shadow of His hand;
He'll be my song and joy through shadows deep;
 He'll lead me all the way to glory land.

Mountain View, Cal.

Located on the District side of Eastern Avenue at Willow Street, the buildings for the general conference headquarters and the Review and Herald Publishing Association were completed in 1906. Trolley service provided a link to Sligo Creek, a mile north. In subsequent years, these facilities greatly expanded as additions wrapped around and engulfed the original structures (see page 104). (Courtesy of Review and Herald Publishing Association.)

The Review and Herald printed weekly newspapers that connected far-flung congregations across the United States, Europe, and Asia. Planning for the move to Takoma Park included coordinating publication so that church members did not miss a single issue. The first edition from Takoma Park, shown here, is dated May 31, 1906. (Courtesy of Review and Herald Publishing Association.)

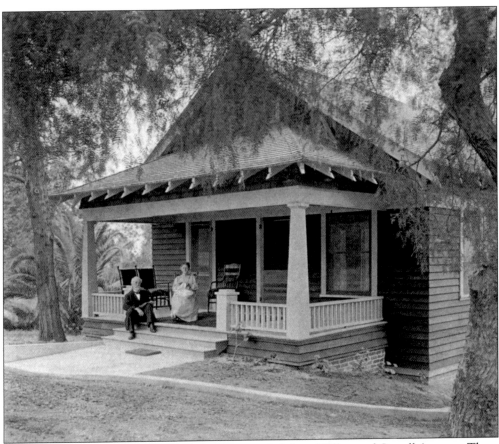

Many church elders like the Irwins, shown here, settled along Willow and Carroll Avenues. These houses helped fill the gap between the original Takoma Park settlement closest to the railroad and the New Takoma section beyond Carroll Avenue. Other Adventists clustered around the campus on Sligo Creek. Over the next decade, the influx of church members spurred Takoma Park's growth. (Courtesy of Review and Herald Publishing Association.)

In need of both a school and a church, the early Adventists combined the functions in one building at 8 Columbia Avenue. The elementary school occupied the first floor, while church services were held upstairs. Worship moved to a new church on Willow Avenue in 1913. The school relocated to 117 Elm Avenue in 1938 and was renamed in honor of John Nevins Andrews, an early Adventist missionary. (Courtesy of John Nevins Andrews School.)

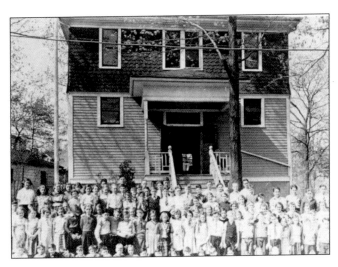

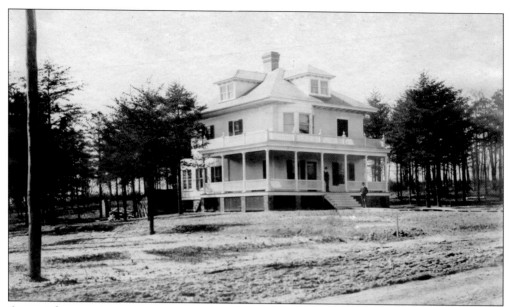

Among the prominent developers joining Gilbert was Heber L. Thornton, who had inherited the Grammar lands adjacent to Gilbert's first purchase. Thornton built this grand house at 516 Cedar Street in 1900, later moving to 500 Butternut Street. Following Gilbert's death in 1907, Thornton assumed the role of primary developer, later adding storefronts along Fourth Street in the District and along Laurel Avenue in Maryland. (Courtesy of Historic Takoma.)

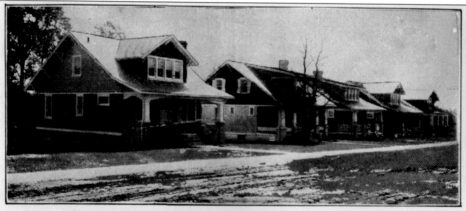

A Few of the "Up-to-date" Takoma Park Houses, Built and Sold by H. L. Thornton.

1 DO YOU KNOW that I always have big bargains on my list of houses and lots, and that it costs you nothing to see them?
2 That my long experience in selling property in this section makes it possible for me to give you the best for your money?
3 That now is the time to buy a house or lot at Takoma Park; the prices will never be lower?
4 That Takoma Park has all the improvements to be found in a city home, and all the advantages of the suburban section?
5 That you can call at my office and get full information, with the assurance that you will not be unduly pressed to buy?
6 That I am the exclusive agent for practically all the best building lots for sale at Takoma Park, and that some of these lots can be sold at extremely low prices?
7 That I can refer you to any one who has had business with me as to my methods?
8 That I am always building for sale attractive houses and bungalows at Takoma Park? See them.
9 That you SHOULD INSURE your property against FIRE with an agent who knows its value.

H. L. THORNTON, TAKOMA PARK SPECIALIST, 500 Butternut St., Takoma Park. City Office, 301 Southern Bldg. Member Washington Real Estate Brokers' Association, and the Washington Board of Trade.

By 1909, Thornton was advertising bungalows along Aspen Street, NW. These inexpensive, easy-to-build homes allowed less affluent middle-class workers to become homeowners, especially when Sears Roebuck and others began offering mail-order kits. Everything needed to build a home arrived by train, ready to be assembled on site. (Courtesy of Historic Takoma.)

Even before the Adventists arrived, Gilbert had been expanding Takoma Park to the north and west. His North Takoma subdivision featured more expensive homes that provided an impressive face along the tracks. The subdivision also boasted its own train stop, as seen at right. (Courtesy of Historic Takoma.)

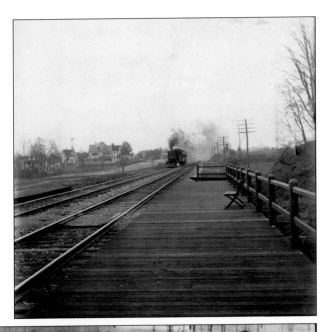

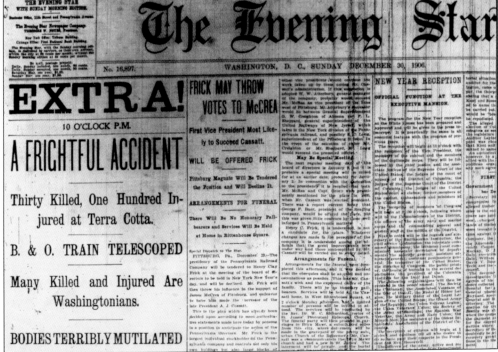

THE EVENING STAR
WITH SUNDAY MORNING EDITION.

The Evening Star

No. 16,897. WASHINGTON, D. C., SUNDAY DECEMBER 30, 1906.

EXTRA!

10 O'CLOCK P.M.

A FRIGHTFUL ACCIDENT

Thirty Killed, One Hundred Injured at Terra Cotta.

B. & O. TRAIN TELESCOPED

Many Killed and Injured Are Washingtonians.

BODIES TERRIBLY MUTILATED

FRICK MAY THROW VOTES TO McCREA

First Vice President Most Likely to Succeed Cassatt.

WILL BE OFFERED FRICK

Pittsburg Magnate Will Be Tendered the Position and Will Decline It.

ARRANGEMENTS FOR FUNERAL

There Will Be No Honorary Pallbearers and Services Will Be Held at Home in Rittenhouse Square.

NEW YEAR RECEPTION

OFFICIAL FUNCTION AT THE EXECUTIVE MANSION

On the night of December 29, 1906, the Takoma stationmaster was alarmed when an empty freight train raced past him barely two minutes behind a slow-moving passenger train. Two miles beyond Takoma at Terra Cotta station (now Fort Totten), the passenger cars were horribly crushed underneath the faster train. Thirty-eight people died, and the *Washington Star* ran banner headlines for weeks. Blame was placed on the freight crew. In 2009, the site was the scene of an eerie reprise of the crash, this time involving Metro trains, which claimed nine lives. In this case, however, officials blamed mechanical failure. (Courtesy of Historic Takoma.)

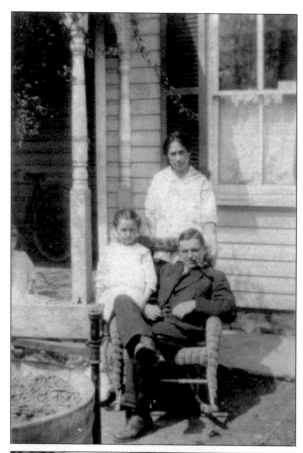

John Gary bought property at the corner of Grant and Hancock Avenues when the old Carroll estate was subdivided into lots. Shown at left in front of his house with his wife and daughter, Gary established a hauling business providing transport to and from the train station. He had sufficient land for a large vegetable garden out back, an echo of Gilbert's original promotions encouraging home buyers to plant gardens as a way to save money. (Both, courtesy of the Hudak-Graul family.)

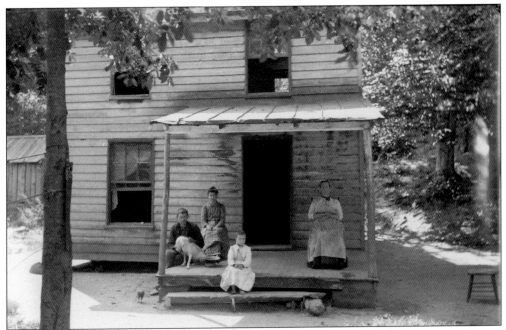

Not all families could afford as sturdy a house as that of the Gary family. This was especially true of the settlers along Maple Avenue between Grant Avenue and Sligo Creek. Two blocks downhill from the Garys, the Redmonds lived in a residence made of board planks with no foundation. Little else is known about them beyond this photograph. (Courtesy of Historic Takoma.)

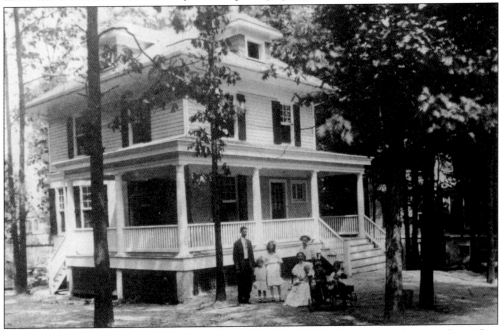

The new residents of 218 Maple Avenue (now 7218) proudly inscribed this photograph as "Our New House, September 1909." Built on a simpler scale than the big Victorians of previous decades, their foursquare still provided for spacious living, with large windows for ventilation and a porch to shield residents from the Washington summer heat. (Courtesy of Historic Takoma.)

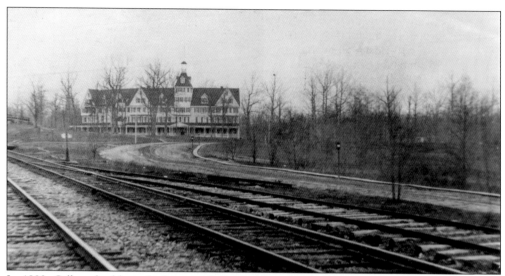

In 1892, Gilbert had launched a grand scheme that ultimately proved to be a failure—a 160-room hotel in North Takoma. He sold his Oak (now Cedar) Avenue house and moved his family on site to oversee construction. The grand hotel finally opened in 1906, but the guests did not materialize. Buffeted by financial woes and rendered infirm by a stroke, he was forced to give up this last dream. (Courtesy of Bliss Electrical School Archives.)

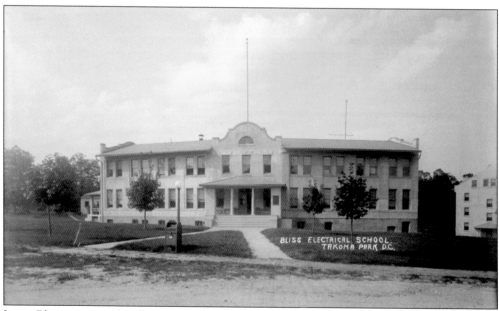

Louis Bliss recognized Gilbert's vacant hotel building as the perfect space for expanding his electrical training school, which at the time offered night classes in the District. Bliss renovated the building as a dorm and classrooms, but two months after Bliss Electrical School opened in 1908, fire destroyed the entire building. With community support, the school remained open and a new building was erected, as shown here. (Courtesy of Bliss Electrical School Archives.)

Mabel Stickney Bliss joined her husband in a house next to the school where she raised their two boys. Professor Bliss headed the school until 1950, when it merged with the fledgling Montgomery Junior College. Based on his training with the Edison Company, Bliss created the first comprehensive one-year program in electrical engineering. (Courtesy of Bliss Electrical School Archives.)

The Takoma Park Citizens Association successfully lobbied for the construction of an elementary school on the DC side to complement the small schoolhouse on Tulip Avenue. The eight-room, single-story building opened in 1901, and overcrowding soon prompted a second-story addition. Interestingly enough, children of parents who worked for the federal government were entitled to attend District schools, and many Maryland families took advantage of this provision. (Courtesy of Historic Takoma.)

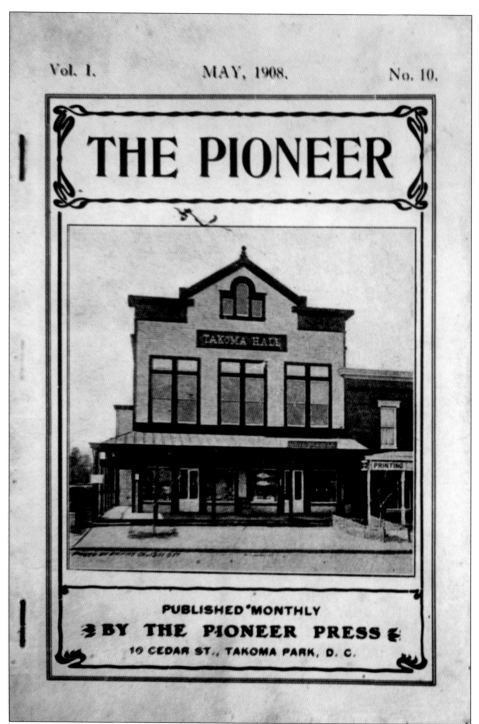

Arthur Skinner set up the Pioneer Press in 1907 and began reporting all the local comings and goings from his offices in Takoma Hall, shown here on the cover of the May 1908 issue. A different landmark was featured on the cover of each monthly edition. His brother Maj. Frank Skinner took over operations in 1920. (Courtesy of Historic Takoma.)

Three

CIVIC LIFE BLOSSOMS
1910–1930

By 1910, Takoma Park was no longer a fledgling settlement but a stable and steadily growing community.

Despite jurisdictional boundaries and the legal separation imposed by the town's incorporation in Maryland, residents remained united by shared institutions, volunteer organizations, and traditions fostered by residents from both the District and Maryland. There were clubs and associations for every age and interest, from the Study Club and Boy Scouts to a local chapter of the Veterans for Foreign Wars, the chamber of commerce, and fraternal organizations like the Lions Club and Masonic lodge. Most mixed pleasure with service. A baseball team and an orchestra formed. The handsome 1911 District Branch Library on Cedar Street, built with Carnegie funding, conveyed a sense of stability and tradition, while a substantial fire station was constructed with rocks carried up from Sligo Creek in 1928. Both offered much-needed meeting space for the multitude of club meetings.

Houses of worship also flourished. The Adventists constructed a new church in the commercial heart of town along the city boundary, while on Maple Avenue, the growing Presbyterian congregation built a Gothic-style granite sanctuary with a lower-level assembly hall for church dinners and other events. On the District side, Baptists and Episcopalians followed suit with stately granite churches on Aspen Street and Piney Branch Road, respectively.

Editors of the *Takoma News* and later the *Takoma Enterprise* publicized all these activities and encouraged their readers to get involved. The citizens' association continued to lobby for projects on both sides of the boundary. Its greatest success was convincing the Baltimore & Ohio Railroad to tunnel under the railroad tracks at the Cedar Street crossroads. Completed in 1912, the underpass transformed the streetscape. Over the next decade, new storefronts expanded local commerce. The Takoma Theatre opened in 1923, soon switching from silent pictures to the wildly popular talkies.

Neighbors on both sides of the town line regularly came together to celebrate. In 1921, the annual Fourth of July celebration was expanded to include a parade, a tradition that continues today. A year later, the Masonic lodge sponsored the Takoma Fair to celebrate the community's general prosperity.

Takoma Club was one of the first groups to organize. Established in 1900, its seal declared its allegiance to both Maryland and District of Columbia. Members gathered at Takoma Hall to debate the hot topics of the day, such as the one advertised here. To support its literary activities, the club opened a lending library next door. (Courtesy of Historic Takoma.)

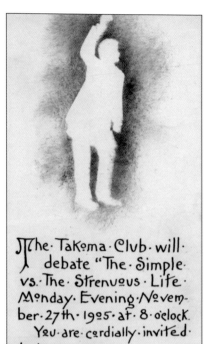

The·Takoma·Club·will· debate "The·Simple· vs.·The·Strenuous·Life· Monday·Evening·November·27th·1905·at·8·o'clock. You·are·cordially·invited· to·be·present. ~ ~ ~ ~~

Takoma residents could chose from over 200 titles in the club library. This early demonstration of a commitment to books and learning was a key factor in Takoma Park's success persuading the District government to award the first branch library to the community furthest away from downtown. (Courtesy of Historic Takoma.)

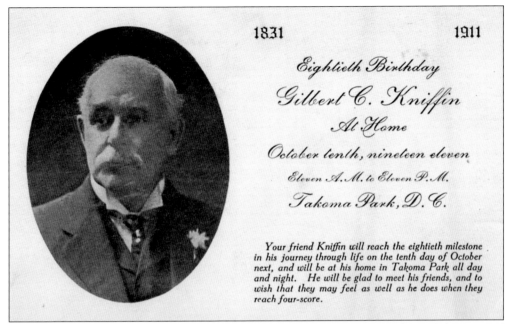

One Takoma Club member, Col. Gilbert Kniffin, used his clout as president of the citizens' association to enlist it in the lobbying effort. One of the first to settle in Takoma Park, he celebrated his 80th birthday the same year the DC branch library opened. (Courtesy of Historic Takoma.)

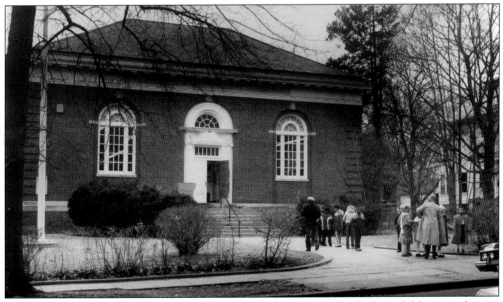

Winning the competition for Andrew Carnegie's $40,000 grant for the branch library took years of concerted lobbying of Congress, which governed DC. Legend has it that one resident (the identity varies) was an acquaintance of Carnegie. True or not, in the end, the locals prevailed, and the elegant Renaissance Revival building on Fifth and Cedar Streets, NW, opened in 1911, quickly becoming the preferred meeting place for local clubs. (Courtesy of Historic Takoma, photograph by Paul McKnight.)

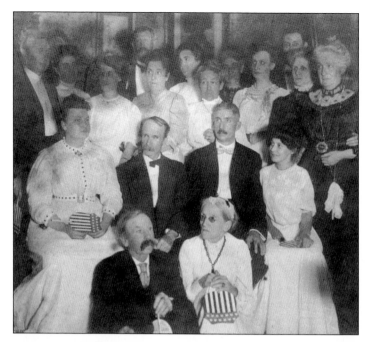

In 1916, many of the earliest residents gathered to form a historical society. Included in this photograph are builder Frederick Dudley Sr. (first row, left) and earliest resident Amanda Thomas (first row, right). Thanks to Dr. William Hooker's efforts to gather photographs, diaries, and scrapbooks from the early years, images like this one survive for subsequent generations. The historical society archives are now in the care of Historic Takoma. (Courtesy of Historic Takoma.)

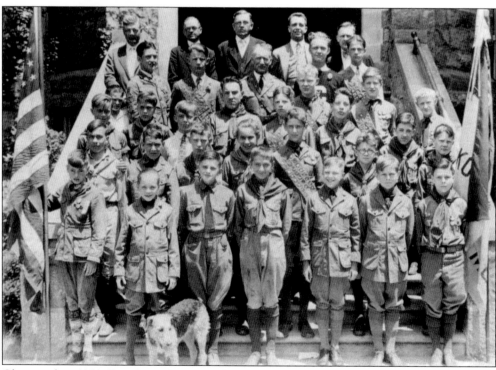

Chartered in 1920, Boy Scout Troop 33 has met at the Takoma Park Presbyterian Church throughout its history. Standing with the scouts (and their canine mascot?) on the church steps, troop leaders in 1927 included Scoutmaster Maj. Frank Moorman (fifth row, third from left) as well as longtime newspaper editor John Coffman Sr. and town historian William Hooker (sixth row, second and third from left). (Courtesy of Boy Scout Troop 33.)

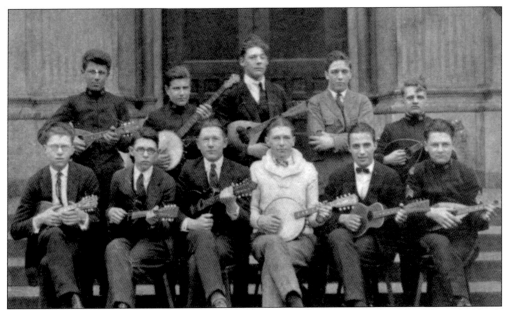

Herman Von Bernewitz (front row, third from left) founded the Takoma Mandoleers in 1923 with 10 friends. Their repertoire of "light-hearted music of the twenties" was arranged for mandolins augmented by guitars, banjos, and bass. Von Bernewitz directed the group for 72 years, until his death in 1995. The Mandoleers left Takoma Park in the late 1930s, but they played at both the 50th and 75th town anniversaries and were still active as of 2010. (Courtesy of Francine Von Bernewitz.)

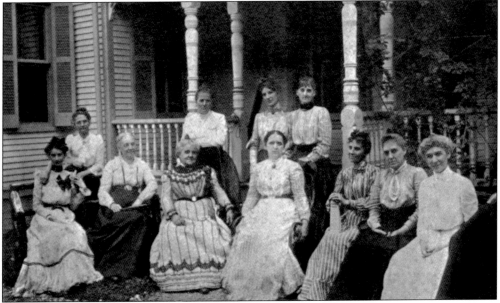

Churches also played a key role in the civic life of the early community. The first ladies' guild of Trinity Episcopal Church gathered at 10 Pine Avenue for this portrait. Trinity Episcopal Church, organized in 1887, met in private homes and halls until the church was built in 1893. The church building, located at Piney Branch Road and Dahlia Street, was constructed on land donated by the Thornton family. (Courtesy of Trinity Episcopal Church.)

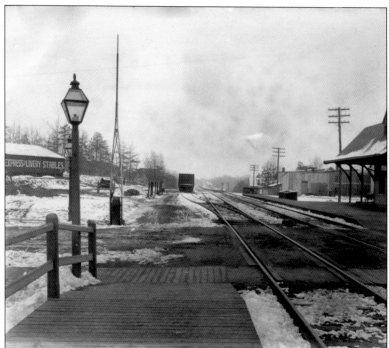

In the early days of Takoma Park, Cedar Street crossed the railroad tracks at ground level, as seen in this early photograph. The lamp post and vertical barricade mark the road's path. The livery stable to the left furnished horses for those residents who housed carriages on their properties. (Courtesy of Historic Takoma.)

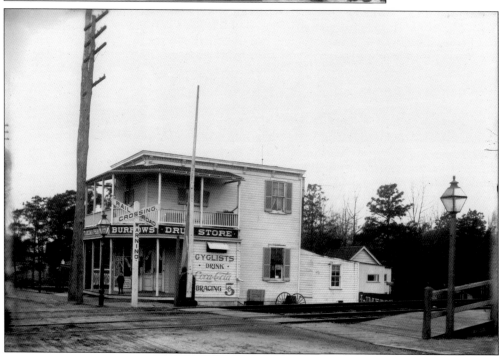

Another view of the crossroads shows Burrow's Drug Store on the northwest corner of the intersection. The citizens' association led a concerted campaign to convince the Baltimore & Ohio Railroad to tunnel under the tracks. A safer bypass would protect the autos and pedestrians who crossed the intersection every day, especially the school children who attended Takoma Elementary School on Piney Branch Road. (Courtesy of Historic Takoma.)

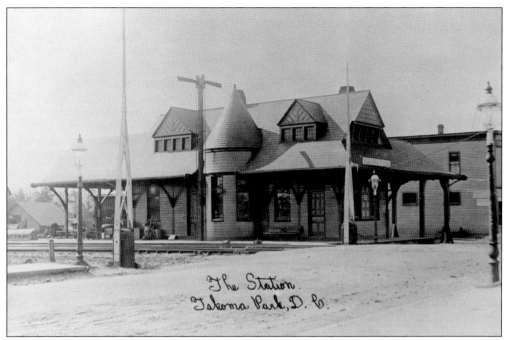

The Station.
Takoma Park, D. C.

Before tunneling began in 1912, the train station stood on level ground, although the land sloped downhill for a block in either direction. In a monumental feat, the Baltimore & Ohio Railroad removed tons of earth, allowing the road to cross the tracks below ground. Afterward, the station stood isolated on an elevated platform that required passengers to climb stairs to catch a train. (Courtesy of the Bien Collection, Historic Takoma.)

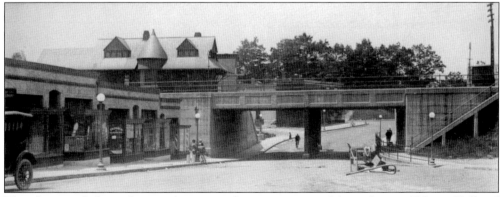

This photograph shows the transformation after construction of the underpass. Takoma Hall and stores adjacent to the tracks suddenly acquired a lower level, and the addition of storefronts at street level (to the left) obscured several stately houses in the block east of the tracks. (Courtesy of Historic Takoma.)

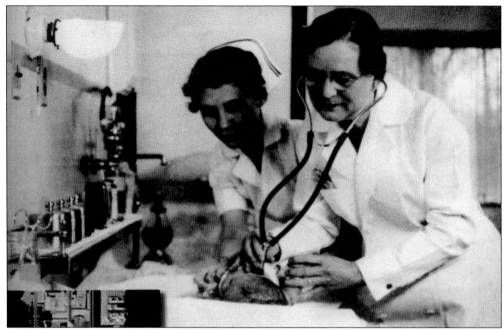

On Sligo Creek, the fledgling sanitarium was expanding under the supervision of its first medical director, Dr. Daniel Kress. One of the staff doctors was his wife, Lauretta, the first woman licensed to practice medicine in Montgomery County. Lauretta Kress opened the Kress Maternity and Children's Hospital adjacent to the San in 1916, and over the next 30 years, she delivered more than 5,000 babies. (Courtesy of Washington Adventist Hospital.)

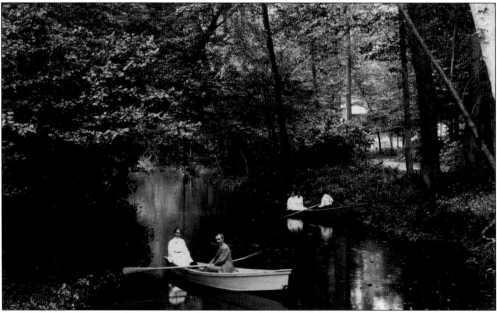

In the 1920s, patients and staff enjoyed boating on Sligo Creek directly below the hospital grounds. The dam and water filtration plant at the foot of Maple Avenue provided a deep pool of water. Notations on the back of this photograph identify Daniel and Lauretta Kress as those seated in the front rowboat. (Courtesy of Ellen G. White Archives.)

Activity at the Review and Herald building grew along with the Adventist missionary outreach. Every week, a fleet of trucks made the short trip from loading dock to the train station, where high stacks of newsletters were loaded onto railcars waiting to be added to passing trains. (Courtesy of Review and Herald Publishing Association.)

In 1915, the first graduating class of Washington Missionary College under its new liberal arts curriculum posed for a formal picture with the college president (third from right). The original mission of preparing students for pastoral service proved too limiting, and the new program attracted a wider range of students. (Courtesy of Washington Adventist University.)

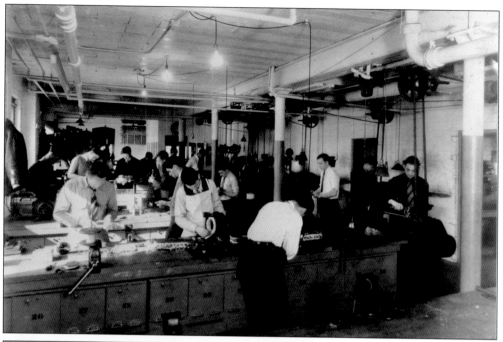

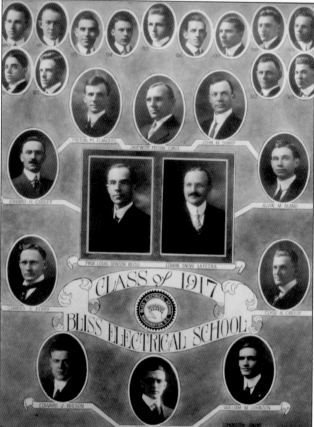

By special arrangement with the war department, Bliss Electrical School provided course materials to train more than 700 drafted men in 1918 alone for wartime searchlight duties. Although some studied in Bliss classrooms, as seen above, many attended school at their bases, and Bliss engineers were also sent abroad to train troops. (Courtesy of Bliss Electrical School Archives.)

This class of 1917 was one of three civilian classes graduating that year. A new group of students formed every four months and rotated through the streamlined course of study designed by Louis Bliss and supported by the three-volume textbook he authored. Bliss insisted on high moral standards for his students, and local girls considered these men to be prestigious dates. (Courtesy of Bliss Electrical School Archives.)

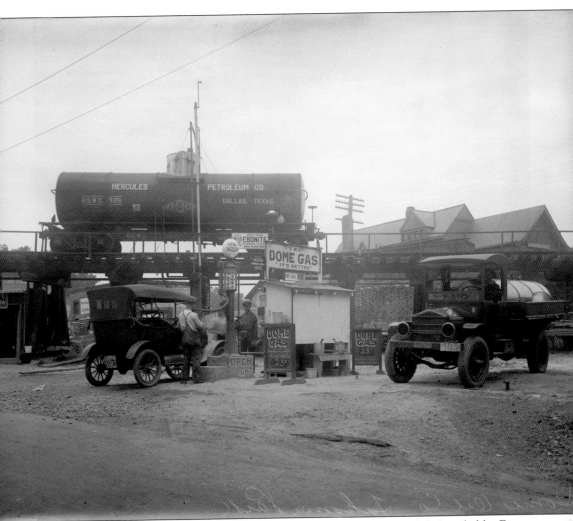

Other technologies were making life easier in the early 1920s. Dome Oil, founded by Ernest Ruebsam, was the first company to offer Takoma Park customers fuel oil stoves to heat their homes. Fuel oil was much cleaner than the coal alternative, and home delivery was much simpler. This 1921 photograph shows the railcars temporarily used as storage before permanent underground tanks were built. Note the train station in the background. (Courtesy of Division of Prints and Photographs, Library of Congress.)

Takoma Park owes its most enduring tradition to the children in local Sunday school classes who suggested in 1921 that a parade be added to the annual Independence Day celebration. The entire community enthusiastically joined in. These children are one of 35 units marching in the first parade. (Courtesy of Historic Takoma.)

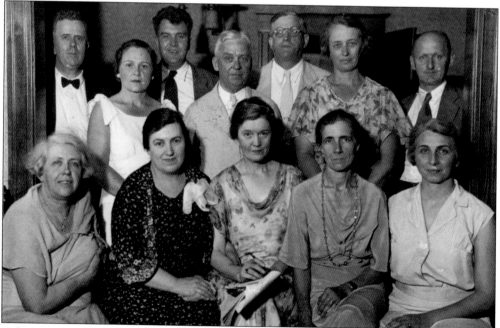

Volunteers organized Takoma Park's first Independence Day activities in 1889, a practice that continues today with broad community participation. The 1927 committee included several prominent women in town, including Ruth Pratt (first row, center), who in the following decades would spearhead the push for a town library. (Courtesy of Historic Takoma.)

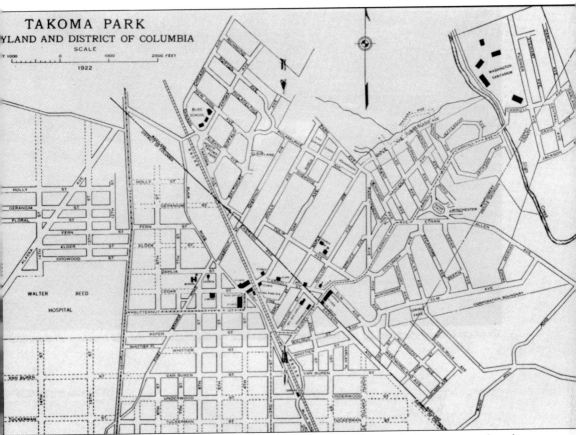

The postwar revival of commerce prompted the Takoma Park Masonic Lodge to stage a four-day Takoma Fair in October 1922. The 48-page program included this map showing development on both sides of the District line. A prosperous town center is shown clustered near the railroad, while undeveloped land still remains on the north and east edges. The open expanse is home to Hodges dairy farm. By 1971, the Philadelphia Avenue Elementary School, Takoma Park Junior High School, Piney Branch Elementary School, the city library, and Takoma Park's first real city hall would replace these hayfields. Spurred by population growth and geographic expansion, residents of the two jurisdictions were beginning to form separate organizations. Although the joint Takoma Park Citizens Association continued through 1949, the community league formed in 1924, allowing only Maryland members; District residents established their own citizens' association in 1925. (Courtesy of Historic Takoma.)

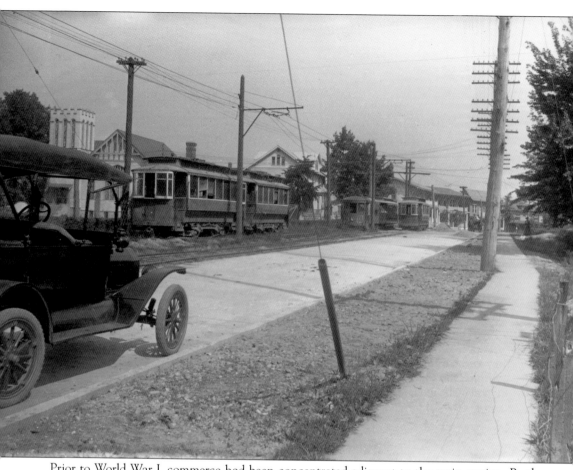

Prior to World War I, commerce had been concentrated adjacent to the train station. By the 1920s, a second commercial center was developing around the intersection of Laurel and Carroll Avenues in Maryland. Here, residents could catch the trolley to downtown Washington or to the hospital on Sligo Creek. Across the street to the left, the Adventist headquarters and publishing facility continued to expand. (Courtesy of Richard Singer Collection.)

Henry Ford's introduction of the Model T in 1908 altered the face of America. By 1920, there were more than 20 million cars on the road. Ads like this one for Hendrick Motor Co. encouraged everyone to own a car. Dealerships sprang up in every small town, including Takoma Park, making it ever easier for a citizen with ordinary means to purchase a new car. (Courtesy of Historic Takoma.)

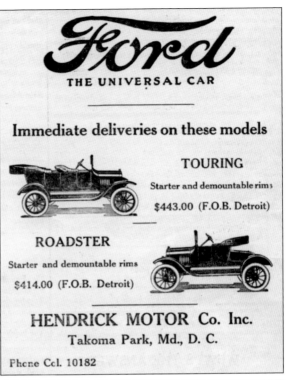

Ford

THE UNIVERSAL CAR

Immediate deliveries on these models

TOURING

Starter and demountable rims

$443.00 (F.O.B. Detroit)

ROADSTER

Starter and demountable rims

$414.00 (F.O.B. Detroit)

HENDRICK MOTOR Co. Inc.

Takoma Park, Md., D. C.

Phone Col. 10182

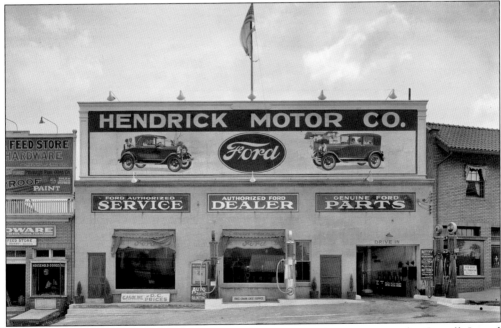

In 1923, H.B. Hendrick's Ford franchise was the most prominent store on the Carroll–Laurel Avenue block. A distinctive showroom window replaced the flat front seen here as part of Milton Derrick's 1940 makeover of what had become Takoma Motor Company. The repair shop entrance moved around the corner to Westmoreland Avenue. Ace Hardware now occupies the building. (Courtesy of Prints and Photographs Division, Library of Congress.)

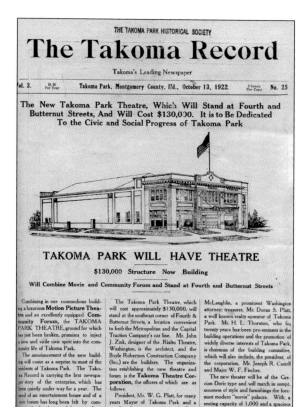

THE TAKOMA PARK HISTORICAL SOCIETY

The Takoma Record

Takoma's Leading Newspaper

Vol. 3. $1.30 Per Year | Takoma Park, Montgomery County, Md., October 13, 1922. | 3 Cents Per Copy | No. 25

The New Takoma Park Theatre, Which Will Stand at Fourth and Butternut Streets, And Will Cost $130,000. It is to Be Dedicated To the Civic and Social Progress of Takoma Park

TAKOMA PARK WILL HAVE THEATRE

$130,000 Structure Now Building

Will Combine Movie and Community Forum and Stand at Fourth and Butternut Streets

Combining in one commodious building a luxurious Motion Picture Theatre and an excellently equipped Community Forum, the TAKOMA PARK THEATRE, ground for which has just been broken, promises to inject a new and virile civic spirit into the community life of Takoma Park.

The announcement of the new building will come as a surprise to most of the residents of Takoma Park. The Takoma Record is carrying the first newspaper story of the enterprise, which has been quietly under way for a year. The need of an entertainment house and of a civic forum has long been felt by community leaders here, and the new theatre is the outcome of many conferences among prominent citizens seeking to promote our local welfare.

The Takoma Park Theatre, which will cost approximately $130,000, will stand at the southeast corner of Fourth & Butternut Streets, a location convenient to both the Metropolitan and the Capital Traction Company's car line. Mr. John J. Zink, designer of the Rialto Theatre, Washington, is the architect, and the Boyle Robertson Construction Company (Inc.) are the builders. The organization establishing the new theatre and forum is the Takoma Theatre Corporation, the officers of which are as follows:

President, Mr. W. G. Platt, for many years Mayor of Takoma Park and a staunch and constant promoter of all its interests; vice president, Dr. E. Clyde Shade, prominent in professional, musical and dramatic circles; secretary, Mr. E.H.

McLaughlin, a prominent Washington attorney; treasurer, Mr. Doran S. Platt, a well known realty operator of Takoma Park. Mr. H. L. Thornton, who for twenty years has been pre-eminent in the building operations and the promotion of widely diverse interests of Takoma Park, is chairman of the building committee, which will also include, the president, of the corporation, Mr. Joseph R. Castell and Major W. F. Fischer.

The new theater will be of the Grecian Doric type and will match in sumptuousness of style and furnishings the foremost modern "movie" palaces. With, a seating capacity of 1,000 and a spacious rostrum of modern design, the auditorium will be amply equipped to accommodate

Continued on page 5

Plans for the Takoma Theatre warranted banner headlines in the 1922 *Takoma Record*. Opening night was a gala occasion, as crowds awaited their first glimpse of the elaborate skylight and satin wallpaper. Located on the corner of Fourth and Butternut Streets, NW, this was the first theater designed by John Jacob Zink, who would go on to create more than 200 such movie houses across the region. (Courtesy of Historic Takoma.)

PROGRAM JULY · · 1928 🇺🇸 TAKOMA THEATRE 🇺🇸 PROGRAM JULY · · 1928

SUN	MON	TUES	WED	THURS	FRI	SAT
RICHARD BARTHELMESS		AMERICAN BEAUTY	WESLEY BARRY	LEATRICE JOY		JACKIE COOGAN
1 \| 2		Double 3 Feature	4	5 \| 6		7
THE NOOSE		UNDER THE BLACK EAGLE	IN OLD KENTUCKY	THE BLUE DANUBE		THE BUGLE CALL
LON CHANEY		LOVE HUNGRY	McDONALD · MORAN · DRESSLER		McKAILL · MULHALL	HAROLD TEEN
8 \| 9		Doub. 10 Feat.	11 \| 12		13	Doub. 14 Feat.
LAUGH, CLOWN, LAUGH		THE PLAY GIRL	BRINGING UP FATHER		LADIES' NIGHT IN A TURKISH BATH	RED RAIDERS
MARION DAVIES		LOWE & MORAN IN "PUBLICITY MADNESS"		CROOK-MELODR.	ALICE WHITE	TOM MIX
15 \| 16		17 Double Feature 18		19	20	21
THE PATSY		A REISSUE OF JOHN GILBERT IN "TRUXTON KING"		SQUARE CROOKS	THE MAD HOUR	ARIZONA WILDCAT
NOVARRO · CRAWFORD · TORRENCE		MAY McAVOY IN "THE LITTLE SNOB"		DOLORES COSTELLO		RIN TIN TIN
22 \| 23		24 Double Feature 25		26 \| 27		28
ACROSS TO SINGAPORE		SYD CHAPLIN IN "THE MISSING LINK"		OLD SAN FRANCISCO		RINTY OF THE DESERT
GEO. O'BRIEN · ESTELLE TAYLOR		COUNT OF TEN				
29 \| 30		Doub. 31 Feat.				
HONOR BOUND		HOT HEELS				

SHOWS—Sunday at 3, 5, 7 and 9 p.m. (continuously). Saturday at 1:15, 3, 7 and 9 p.m. Other days at 7 and 9 p.m. (The Saturday 5 o'clock show has been discontinued for the summer months)

As shown in this schedule from July 1928, Takoma Theatre offered five features each week. Saturday afternoon matinees were popular with area children, while newsreels between features kept the community informed of world events. The theater operated until the mid-1970s and then briefly presented live performances. As of 2010, the Takoma Theatre Conservancy continues to explore options for preserving the building as a theater. (Courtesy of Historic Takoma.)

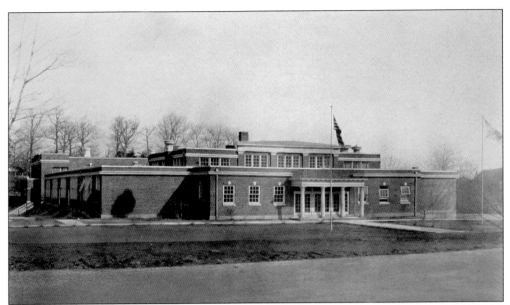

Takoma–Silver Spring High School opened in 1924 at the corner of Philadelphia and Chicago Avenues. Outgrowing the space in four years, grades 10 through 12 relocated to the newly completed Montgomery Blair High School on Wayne Avenue in Silver Spring. The old building continued as an intermediate school until 1971. Today, only a stone foundation and basketball court remain to mark the site. (Courtesy of Montgomery Blair High School.)

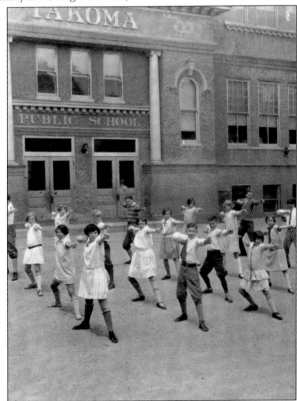

Beginning in the 1920s, physical exercise became an important component in school programs. Students at Takoma Elementary School can be seen engaging in daily activities that were repeated in schools across the country. Note the student dress typical of the 1920s. (Courtesy of Historic Takoma.)

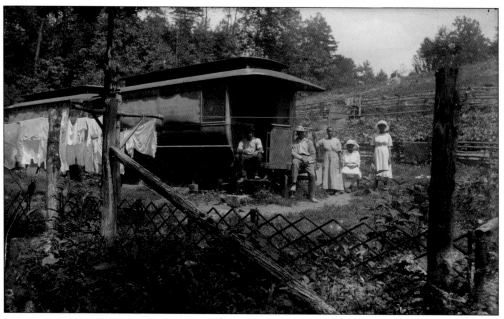

The area along Maple Avenue was also home to this enterprising African American family. The streetcar they adapted to provide shelter, built about 1900, likely saw service for 20 years before being taken off the tracks and moved to this location near Grant Avenue. (Courtesy of Historic Takoma.)

Home Dairy, featured in this *Takoma News* ad, was one of four serving Takoma Park. Owned by Roger Hodges, it was bounded by Maple Avenue, Philadelphia Avenue, and Piney Branch Road (see map on page 53). Retiring in 1932, Hodges became a part-time policeman, and his 400 acres provided land for new schools and public buildings. (Courtesy of Historic Takoma.)

The main enclave of Takoma Park's African American community was located on Ridge Avenue (now Ritchie Avenue), which marked the northern edge of Hodges farm. In 1920, the community began providing religious training for local black children under the leadership of Rev. William Parker. By 1926, the community laid the cornerstone for the First Baptist Church of Takoma Park at Geneva and Ritchie Avenues (renamed Parker Memorial Church in 1956). (Courtesy of the Warren-Jordan families.)

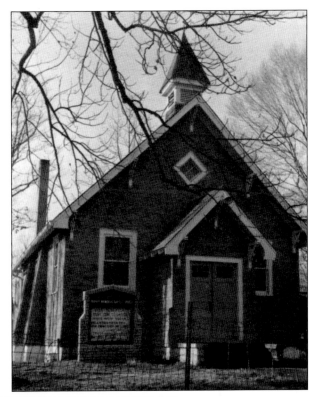

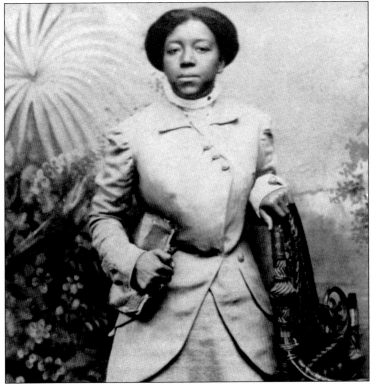

This portrait of May Olive Warren was taken in 1914, shortly before she came to live in Takoma Park. She raised a family on Ritchie Avenue, and her daughter married Lee Jordan, founder of the Takoma Park Boys and Girls Club. (Courtesy of Warren-Jordan families.)

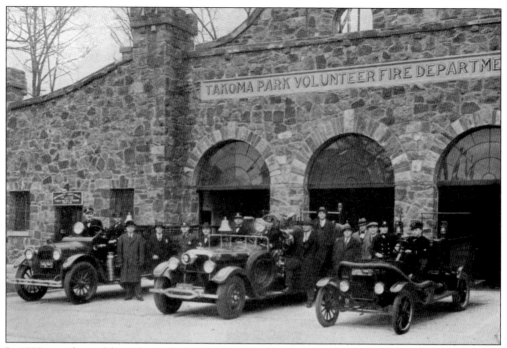

In 1928, members of the Takoma Park Volunteer Fire Department dragged boulders from Sligo Creek to construct the facade of their new station at the corner of Carroll Avenue and Denwood (now Philadelphia) Avenue. This structure marked the beginning of development at the Carroll–Ethan Allen Avenue intersection. The storefronts here came to be known as the "halfway stores," because they marked the midway point on the Dinky trolley run between old Takoma and Sligo Creek. Fire department members staged a water hose battle (below) as part of the 1924 Independence Day festivities. (Both, courtesy of Historic Takoma.)

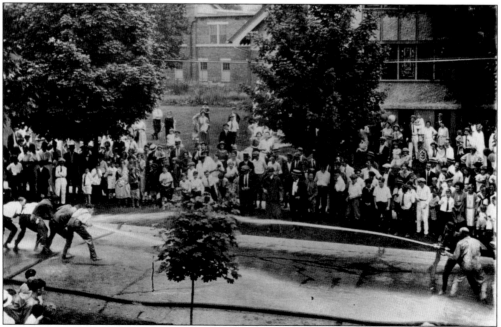

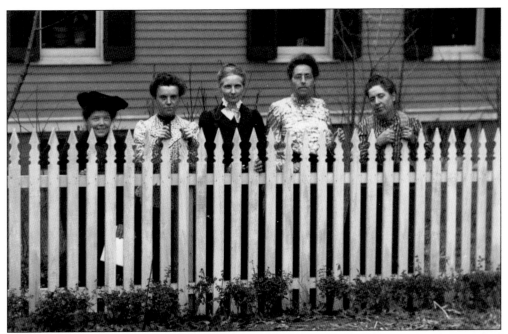

Many civic improvements were conceived in ladies' social circles. Morris Bien took this photograph of five neighbors on Montgomery Avenue. They are, from left to right, Mrs. Barhitz, Ethel Mooers, Mrs. Harrison, Mrs. Shearn, and Mrs. Mooers. (Courtesy of the Bien Collection, Historic Takoma.)

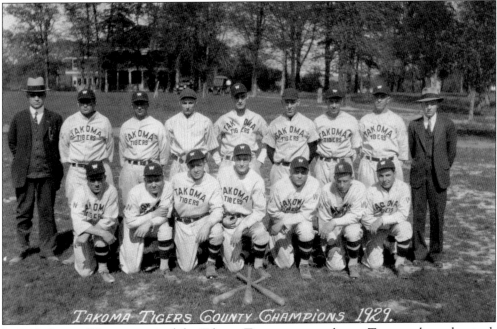

In 1919, Garrett Waters organized the Takoma Tigers as young players. Ten years later, they took the first championship in the newly organized Montgomery County League. The team is shown here with manager Joseph Simpson at left and Coach Waters at right. The team went on to earn the Capital City League crown in 1930 and 1931, defeating the Virginia, Prince George's, and District champions. (Courtesy of the Simpson-Lorentz family.)

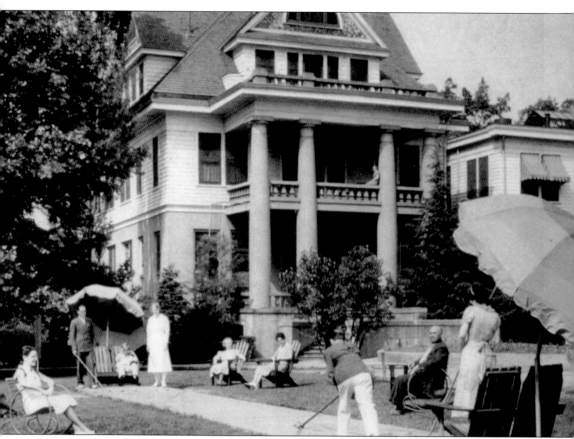

Meanwhile, the Sanitarium was prospering on the bank of Sligo Creek. Patients, such as those seen here enjoying a game of shuffleboard, were treated with a regimen of rest, vegetarian meals, and moderate exercise. (Courtesy of Washington Adventist Hospital.)

Four

FACING DEPRESSION
AND WAR
1930–1945

Even as the Great Depression rocked the nation, Takoma Park maintained a solid footing, thanks to its base of federal and Adventist employees. In 1933, early civic leaders were recognized in an Old Settlers Banquet held to mark the town's 50th anniversary. Gilbert Memorial Park, at Eastern Avenue and Piney Branch Road, was designated in honor of the town's founder in 1939. With 12,000 residents at this time, Takoma Park was the eighth largest city in Maryland, a reflection of how the increase of automobiles was spurring the growth of suburbs in Montgomery and Prince George's Counties. A new steel bridge soon graced Sligo Creek at Carroll Avenue, while on Takoma Park's perimeter, New Hampshire Avenue, University Boulevard, and Piney Branch Road were widened and extended as more automobiles competed with trains and streetcars.

As B.F. Gilbert had hoped, the citizens of Takoma Park continued to establish community institutions and encourage participation on the part of all residents. Ruth Pratt prodded the town to open a library on the Maryland side. Horticultural club members organized annual flower sales as the results of Ben Morrison's azalea experiments made their way into yards all over Takoma Park.

The bombing of Pearl Harbor on December 7, 1941, and America's entry into World War II brought yet another influx of workers to the nation's capital, particularly the "dollar-a-day men" who came to staff wartime agencies in the federal government and the "government girls" who left small towns across the country to come to Washington to work as secretaries, nurses at Walter Reed Hospital, or technicians at the Washington Navy Yard. Some older city residents still remember the excitement of having young single women board with local families. Like Americans across the country, the people of Takoma Park purchased war bonds, planted victory gardens, redeemed ration stamps, and hung blackout curtains. Bliss Electrical School trained 4,000 enlisted men.

Everyone looked forward to peace.

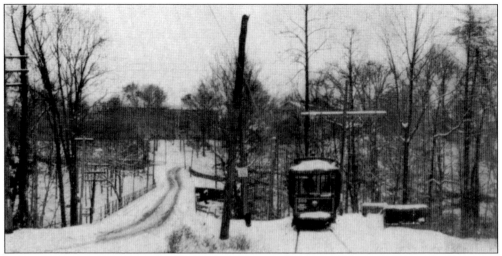

After Wildwood resort closed in 1901, the Dinky trolley line was rerouted directly up Carroll Avenue to the Adventist hospital and the college on Sligo Creek. The small cars (out-of-date hand-me-downs from other trolley lines) were beloved by the students, who counted on them for a quick ride to town. (Courtesy of Washington Adventist University.)

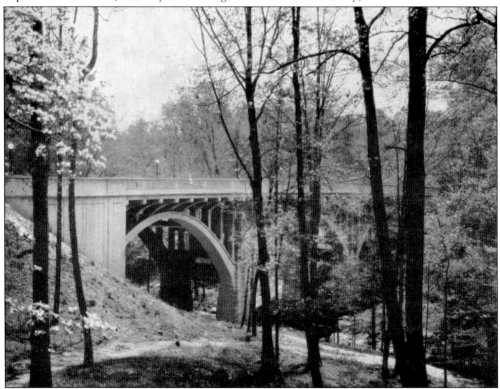

Maryland governor Albert Ritchie was on hand along with thousands of spectators on April 16, 1932, to dedicate the new Sligo Creek Bridge, a three-lane concrete span costing $60,000. The bridge provided a convenient and scenic amenity for motorists and pedestrians traveling to the hospital, the campus, and along the Sligo Creek Parkway, and it remains so today. (Courtesy of Washington Adventist Hospital.)

In 1933, Dr. William Hooker, president of the historical society, compiled a history of Takoma Park as part of the 50th anniversary of the town's founding. The oldest settlers gathered for a banquet at the fire station, where the Takoma Mandoleers were the featured orchestra. (Courtesy of Historic Takoma.)

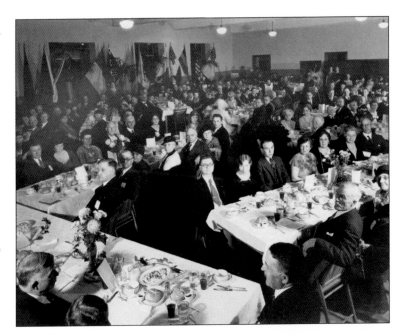

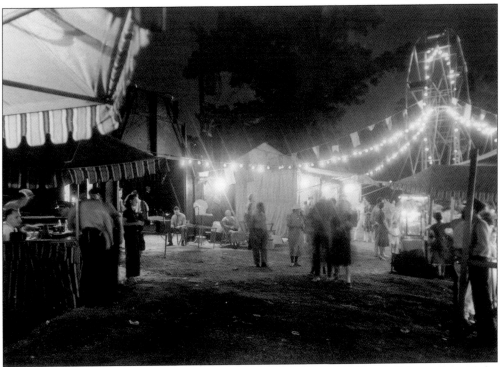

Every summer during the 1930s, residents across Takoma Park, black and white, welcomed the arrival of the carnival. Setting up in the open space between the fire station and Ethan Allen Avenue, the carnival was a fundraiser for the fire department. Storefronts were beginning to appear on the block around the curve heading toward Sligo Creek, but the area known today to as Takoma Junction was slow to develop. (Courtesy of Historic Takoma.)

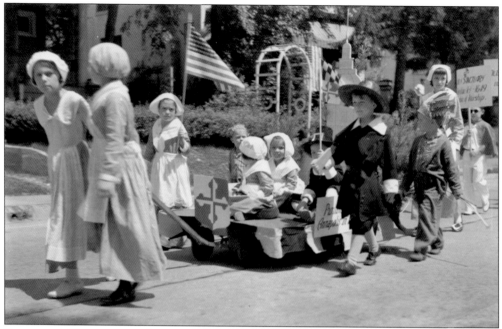

For many children, summer days were also spent creating a float for the Independence Day parade. This group from Elm Avenue marched in 1932, representing the hardy souls who founded Maryland in search of religious freedom. The tall girl to the right is a young Dorothy Thomsen (Barnes), Historic Takoma's resident historian. (Courtesy of Historic Takoma.)

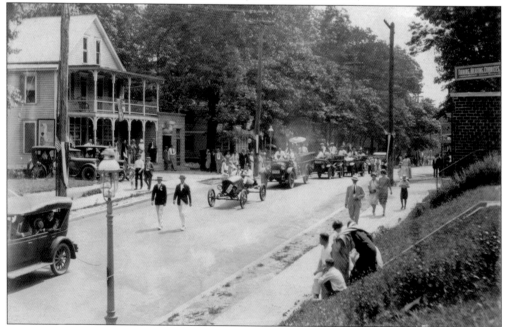

Several motorcars are part of the same parade, making their way west on Carroll Avenue toward the underpass. The building with the two-story porch is Favorite's store, rebuilt near Maple Street after the 1893 fire. The stairs at the right give an indication of how much ground was removed to redirect the road under the tracks. (Courtesy of Historic Takoma.)

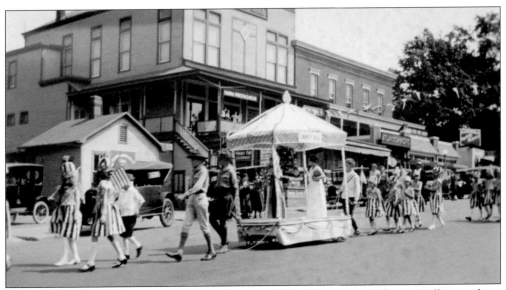

The parade route takes this group of marchers up Cedar Street past Takoma Hall, now three stories tall. Prior to the underpass construction, this building was only two stories (see page 40). This block of Cedar Street was rerouted eastward when the Metro station was built in the late 1970s. (Courtesy of Historic Takoma.)

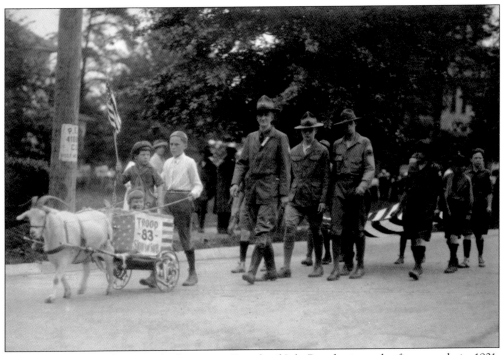

Boy Scout Troop 33 has marched in every Fourth of July Parade since the first parade in 1921. Chartered in 1920, Troop 33 is one of the oldest active troops in the country. (Courtesy of Historic Takoma.)

The Great Depression meant hard times for the local merchants in particular, and Feldman's Department Store on Cedar Street, just west of the underpass, ran a series of ads in the *Takoma Enterprise* urging residents to shop local, a battle cry that has been revived since the late 1990s. (Courtesy of Historic Takoma.)

The chamber of commerce was organized around the same "buy local" theme, promoting local businesses in this 1938 directory. Under Pres. Heber L. Thornton, the group also lobbied for road expansion, urging that New Hampshire Avenue and University Lane should be widened north the District line. This opened the way for eight new subdivisions along this corridor. (Courtesy of Historic Takoma.)

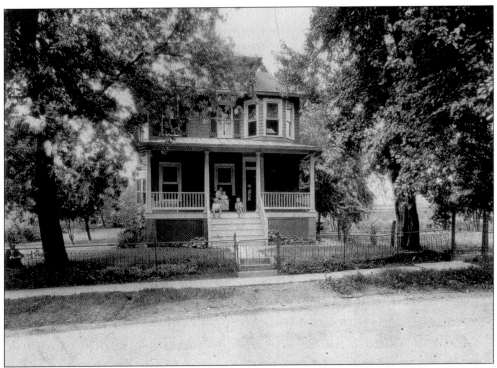

Closer to home, the widening of Piney Branch Road claimed much of Chestnut Avenue and meant displacing several homes that stood in the way. To save their house, the Dawkins family chose to move it from No. 4 to No. 117 on Takoma Avenue (above). It took six months to accomplish the task using greased timbers and a plow horse. (Both, courtesy of the Dawkins Family Collection, Historic Takoma.)

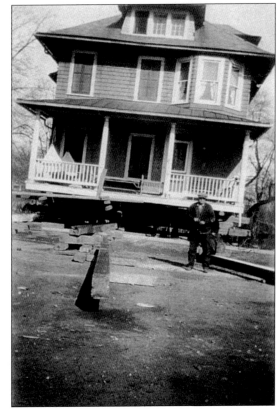

One of B.F. Gilbert's lasting legacies was the recruitment of US Department of Agriculture scientists, who transformed the rural landscape with their horticultural talents. Chief among them was Benjamin Y. Morrison, whose decades of breeding azaleas resulted in 450 new varieties. Officially, his work was done at the Glenn Dale Experimental Station, but he shared many of his azaleas with neighbors in Takoma. (Courtesy of Hunt Institute Archives at Carnegie-Mellon University.)

Morrison took a turn as president of the Takoma Horticultural Club in 1925, then focused his attention on launching the *National Horticultural Magazine*. In his years as editor (1926–1963), he often turned out the monthly issues single-handed. A gifted artist, his woodcuts graced most of the magazine's covers. He continued editing after his 1937 appointment as first director of the National Arboretum, which still displays his extensive azalea collection. (Courtesy of the American Horticultural Society Archives.)

The NATIONAL HORTICULTURAL MAGAZINE

JANUARY - - - 1927

Other prominent members of the horticultural club included Clarence and Lottie Smith. This 1935 image shows their garden in full bloom. The club dates to 1916, making it the second oldest in the United States. Until the beginning of the 21st century, its members sponsored several flower shows a year along with annual plant exchanges. (Courtesy of Historic Takoma.)

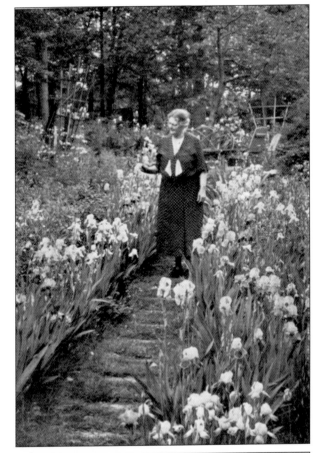

This Fourth of July speech took place in 1939 at Chicago and Takoma Avenues, a popular outdoor venue. Called North Takoma Park until 1930, it became Washington Park, then Jequie Park in 1963, and was renamed Belle Ziegler Park in 2010. (Courtesy of Historic Takoma.)

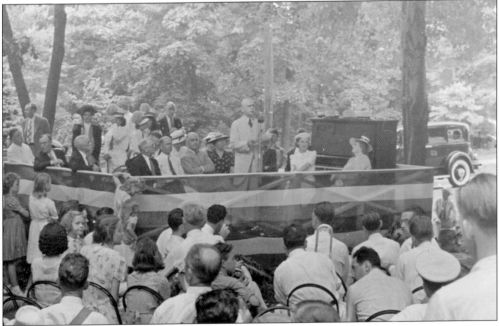

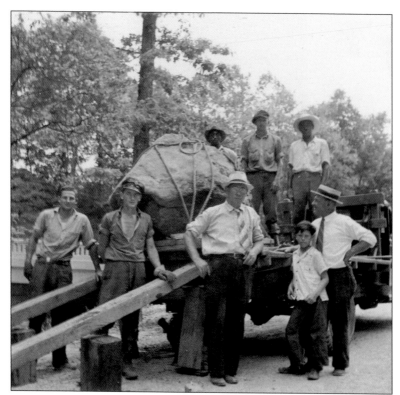

In 1939, the town honored B.F. Gilbert's birth by declaring that the small open lot at the corner of Eastern Avenue and the newly widened Piney Branch Road would be known as Gilbert Memorial Park. A group of men dragged a five-ton boulder out of Sligo Creek to serve as the base for the brass marker honoring the suburb's founder. (Courtesy of Historic Takoma.)

The boulder was installed among flowering shrubs and trees. According to Lee Grabill's original design, shown here, this park marks the northwest corner of Gilbert's first land purchase. Little of the original design can be detected in the park today. (Courtesy of Historic Takoma.)

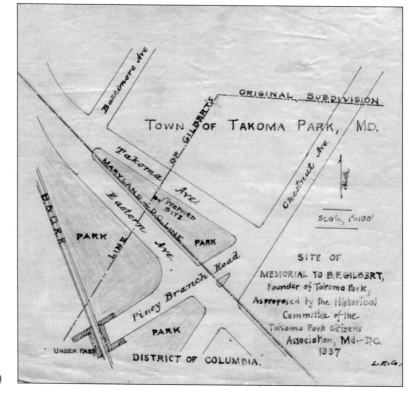

Takoma Park Junior High was completed in 1939 on land that once belonged to Hodges dairy farm. It opened with grades seven through nine. In the days before *Brown v. Board of Education*, it served white students only. The African American school was four blocks away on Geneva Avenue. (Courtesy of Takoma Park Middle School.)

Thanks to the efforts of the joint citizens' association, Northern Senior High (now Coolidge) opened in 1941. Located next to the Takoma Recreation Center and swimming pool, the school was able to take advantage of these amenities. The association was the leader in the movement to provide free textbooks for high school students. (Courtesy of Coolidge High School Alumni Association.)

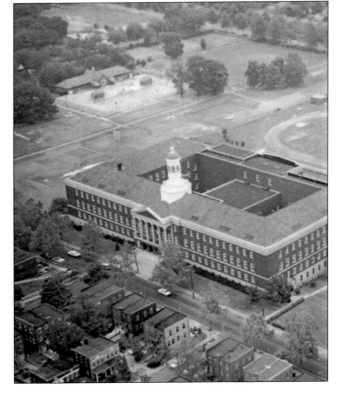

ONE CALL

THE GROUND OBSERVER CORPS

The war years brought hardships to Takoma Park but fostered a sense of communal duty. Neighbors helped each other with victory gardens and went on evening patrols to ensure that blackout curtains were drawn. Still others volunteered for the Ground Observer Corps, taking overnight shifts to keep a lookout for enemy planes at the observation tower in Prince George's County built by Takoma American Legion Post 28. (Courtesy of Historic Takoma.)

Like thousands of other couples who married in the midst of wartime, Elizabeth Findlay and John Degen celebrated their September 17, 1943, wedding day with a tinge of sadness over the separation that lay ahead. The Degens were reunited at war's end and enjoyed a long, active life in Takoma Park. (Courtesy of Elizabeth Findlay Degen.)

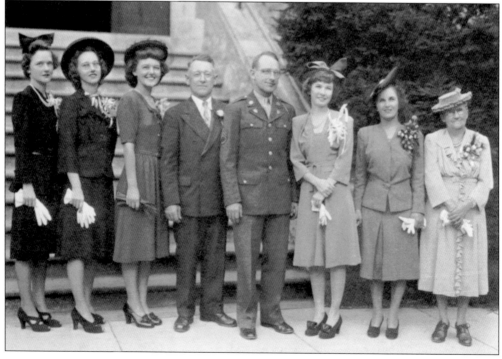

Five

THE EXPANDING SUBURBS
1945–1960

The end of the war brought more change.

Returning soldiers filled new apartment buildings, especially along University and New Hampshire Avenues. Shopping centers followed, offering convenience and choice but drawing customers away from the stores in town. The GI bill prompted many veterans to enroll in Montgomery Junior College. Older houses that had been subdivided for boarders during the war came under city council regulation in 1953.

The town of Takoma Park became a city in 1949, when a new generation of community leaders ushered in a formal administrative structure reporting to the mayor and council. Soon, the city installed high-powered streetlights, built a modern library building, started using voting machines, and welcomed its first official post office, located just over the Maryland line on Maple Avenue. The police force swelled to 19 members and moved into the first official city hall at the old 8 Columbia Avenue Adventist school building. Progress forced the city to seal Big Spring in 1948, because it had become too polluted to serve as a source for drinking water.

Young black veterans returned to a still-segregated Washington with limited opportunities for employment. In Takoma Park, the African American community was centered along Ritchie and Geneva Avenues off Piney Branch Road and at Cherry and Colby Avenues near Sligo Creek. Black and white children came together to play sports in leagues organized by Lee Jordan, an elder at Parker Memorial Church. Under Jordan's gifted leadership, these activities contributed to a sense of shared community that would later help see the town through desegregation.

Anniversary events continued to mark milestones in the community's history. In 1950, civic leaders prepared an impressive publication commemorating the 60th anniversary of the city's incorporation. Eight years later, a four-day extravaganza celebrated founding day. Floats, athletic competitions, and fireworks brought everyone together each Fourth of July.

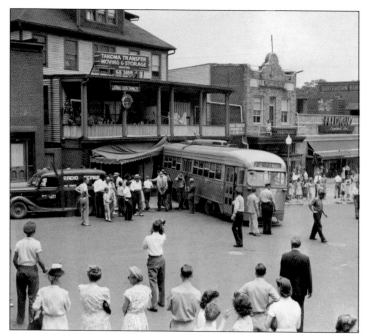

On a summer day in 1946, a runaway trolley jumped its track at the Fourth Street end of the line, careening into the plate glass window of the Transit Company. By then, rail service had been reduced to three trains a day, and residents relied almost entirely on trolleys to get downtown. By 1960, the District transit authority had prevailed in its efforts to replace all trolleys with bus lines. (Courtesy of DC Public Library, Star Collection, © *Washington Post.*)

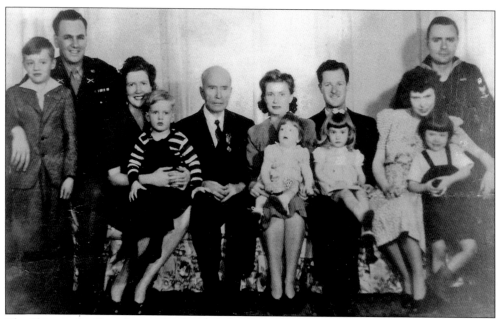

The Skinner family gathers around patriarch Frank Skinner in 1947. One of the original settler families, the clan grew up at 49 Sycamore Avenue. Frank, a big booster of the local economy, took over the Pioneer Press from his brother in 1920. His twice-a-year issues of the *Takoma Enterprise* profiled local businesses and civic institutions. (Courtesy of the Skinner family.)

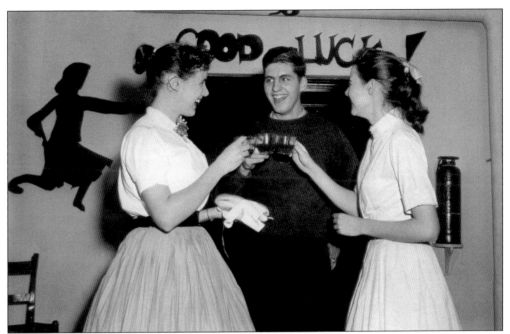

Like other churches in town, Takoma Park Presbyterian Church offered a safe place for teenagers to congregate for social activities. Parents also gave permission for dances or roller skating in the gym in the basement of the fire station and for weeknight excursions to the library on Sherman Avenue. (Courtesy of Takoma Park Presbyterian Church.)

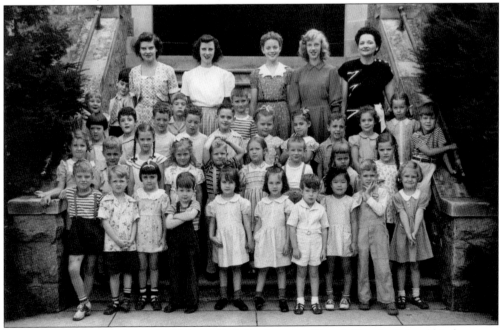

This 1947 photograph shows the Takoma Park Presbyterian Church Sunday School kindergarten class. The church had recently added a gym and social hall along the Tulip Avenue side of the property. Nearly all Takoma Park families attended neighborhood churches and participated in their educational and social activities. (Courtesy of Takoma Park Presbyterian Church.)

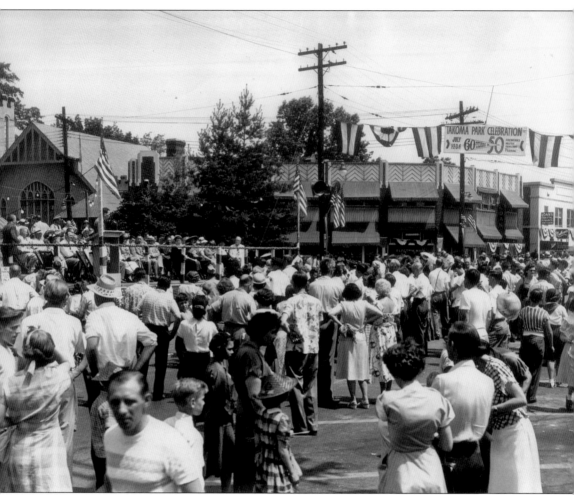

Takoma Park residents gathered at the intersection of Laurel and Carroll Avenues on Fourth of July in 1950 as part of the four-day celebration honoring 60 years of incorporation. The 1913 Adventist church on the left was soon to be replaced by a new church directly across the street. Two of the prominent businesses are barely visible in the photograph: the Electrik Maid bakery in the corner storefront and Hawn Jewelers, owned by the parents of Goldie Hawn, in the far right building. (Courtesy of Historic Takoma.)

The Takoma Park campus of Montgomery College was established in 1950, when Louis Bliss transferred the buildings and grounds of Bliss Electrical School to Montgomery Junior College, shown in the aerial view above. The college had opened in Rockville in 1948 in response to returning veterans clamoring to take advantage of the GI Bill of Rights, which included free vocational and college education. The arrangement with Bliss provided much-needed campus space. Bliss Electrical School had made the shift from training active military to educating veterans, and 2,000 returning soldiers went through the program before the school was fully integrated into the junior college. The plaque below, commemorating the transfer of Bliss School to the college, hangs in the Bliss Alumni Room on the Takoma Park campus. (Both, courtesy of Bliss Electrical School Archives.)

BLISS TECHNICAL BUILDING

NAMED IN MEMORY OF

LOUIS D. BLISS

FOUNDER AND PRESIDENT OF THE
BLISS ELECTRICAL SCHOOL 1893-1950
THE SCHOOL OCCUPIED THIS CAMPUS
FROM 1908 TO 1950
PRESENTED BY THE BLISS ELECTRICAL SOCIETY

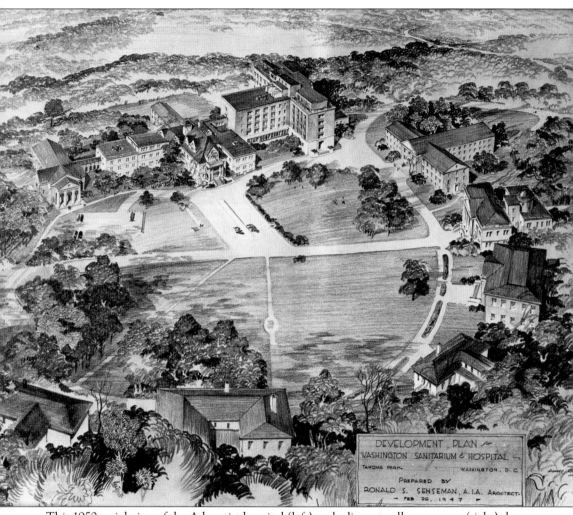

DEVELOPMENT PLAN for
WASHINGTON SANITARIUM & HOSPITAL
TAKOMA PARK WASHINGTON, D.C.
PREPARED BY
RONALD S. SENSEMAN, A.I.A. ARCHITECT.
FEB 26, 1947

This 1950 aerial view of the Adventist hospital (left) and adjacent college campus (right) shows a modern hospital building in the shadow of the 1907 structure. The design was the work of architect Ronald Senseman, a graduate of the college, who was much in demand as a local architect. In 1961, the hospital assumed the more modern name of Washington Adventist Hospital. Then, in 1982, the old San was demolished, much to the dismay of local residents, to make way for parking. Two decades later, the need for more expansion prompted the hospital to look elsewhere, and in 2007, it announced plans to relocate eight miles north. Meanwhile, the college expanded its enrollment as Columbia Union College in 1961 and then as Washington Adventist University in 2010. (Courtesy of Review and Herald Publishing Association.)

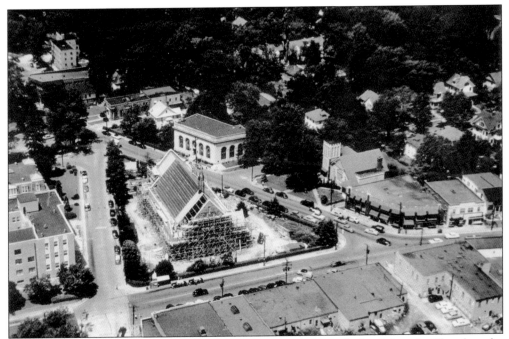

Senseman was also the architect for the new Takoma Park Seventh-day Adventist Church at the Laurel–Carroll Avenue intersection. This 1952 bird's-eye view shows the church under construction on what had been previously been an open triangle planted with grass. The white building with arched windows is the Takoma Park Bank Building, and the curved storefronts mark the Laurel–Carroll Avenue intersection. (Courtesy of Review and Herald Publishing Association.)

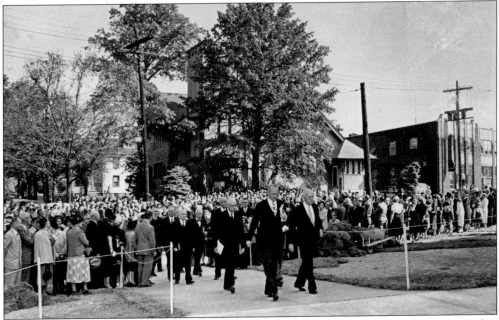

On July 20, 1953, the Adventist pastors led a procession from the old sanctuary to the new Gothic Revival church across the street. The 1913 building was later demolished to make way for church parking. (Courtesy of Review and Herald Publishing Association.)

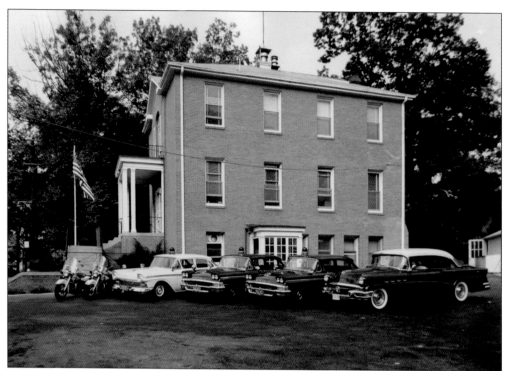

Once Takoma Park became a city in 1949, it set out to operate the government in a more professional manner. The city purchased the old Adventist school at 8 Columbia Avenue (above) for municipal offices. Members of the police department joined other city workers at the new municipal building in 1953. (Courtesy of Historic Takoma.)

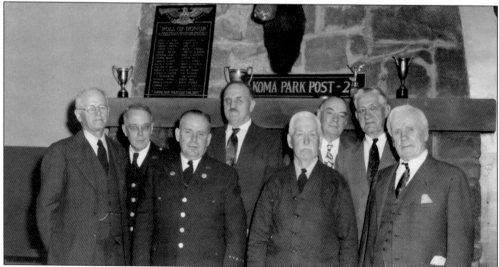

After more than 50 years of independence, leaders of the Takoma Park Volunteer Fire Department agreed to become a city department as part of the reorganization. Officers shown include John Coffman, second from right, publisher of the weekly *Takoma Journal*. (Courtesy of Historic Takoma.)

In 1951, a new one-story brick building at the corner of Philadelphia and Maple Avenues became the first permanent home for the library in Takoma Park, Maryland. Under the auspices of the Women's Club, Ruth Pratt (right) had begun campaigning for a library as early as 1935. She had served as librarian at three temporary locations and continued in the new building until her retirement in 1958. (Courtesy of Historic Takoma.)

The Veterans of Foreign Wars organized a collection drive to raise money for a war memorial. Erected in the triangle park across from the new library, this monument was dedicated on Memorial Day, 1957. (Courtesy of Historic Takoma.)

Prior to the 1954 Supreme Court decision in *Brown v. Board of Education*, Takoma Park's white and black children attended separate schools. African American students had been attending classes in this two-room cement building at 120 Geneva Avenue near Ritchie Avenue since 1935. The school had been built with assistance from Parker Memorial Church and the Julius Rosenwald Fund, which helped construct schools for black children all over the South. The school's 30 students entered white classrooms for the first time in 1955. The Geneva Avenue school building was later reopened as a childcare center, as shown here.(Courtesy of Historic Takoma.)

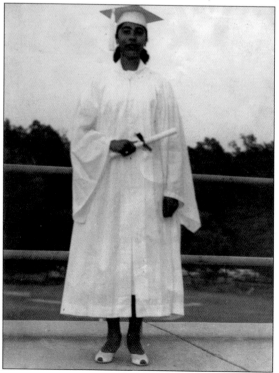

Thelma Ann Dawes stood at the top landing of the stadium bleachers for this photograph in June 1957, the first year Montgomery Blair High School's graduating class included African Americans. One of six children, Thelma grew up on Oswego Avenue, with her grandparents, aunts, uncles, and cousins living nearby. She attended the Geneva Avenue Colored School for first through sixth grades. (Courtesy of Dolly Davis.)

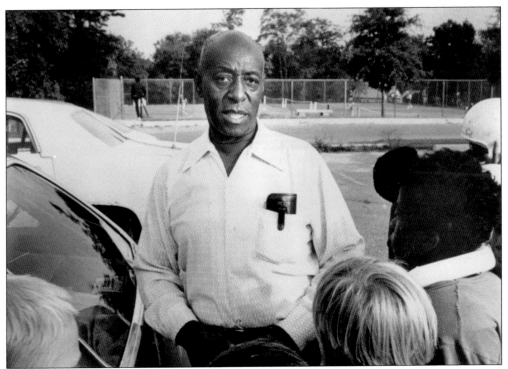

Leaving behind baseball's Negro Leagues in the early 1930s, Lee Jordan returned to Takoma Park and began organizing football, basketball, and baseball for local kids. Expanding the Parker Memorial Church teams of 1937 into the Takoma Park Boys Club, he took the first integrated teams into Montgomery County, eventually adding girls to his rosters. He inspired youth and adults alike, and his leadership helped cushion the upheavals of integration. (Courtesy of the Jordan family.)

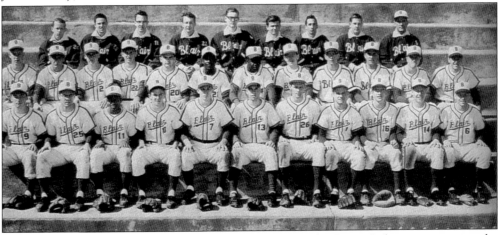

In anticipation of integration, Jordan singled out eighth-grader Sonny Jackson to mentor as the first African American to play on Montgomery Blair High School teams. A talented athlete, Jackson, seen in the photograph above third from left in the front row wearing the No. 11 jersey, excelled in football, basketball, and baseball. After his graduation from Blair in 1962, Jackson turned down a football scholarship as the first black athlete at University of Maryland in order to play baseball with the Houston Astros. (Courtesy of Montgomery Blair High School.)

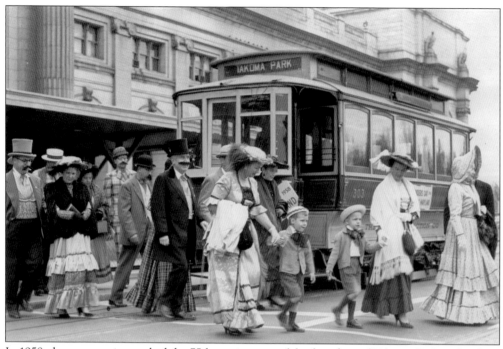

In 1958, the community marked the 75th anniversary of the founding of Takoma Park with a four-day celebration. Residents donned Victorian clothes and took special trolley rides into downtown Washington. The chamber of commerce produced a commemorative brochure detailing the town's achievements over the decades. (Courtesy of Historic Takoma.)

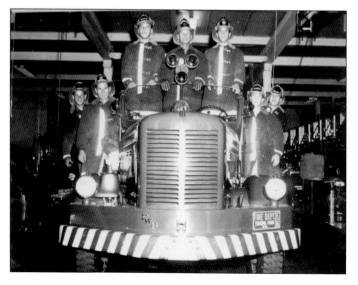

Volunteer firefighting is an honored tradition in the Jarboe family. In 1959, seven Jarboes climbed aboard a fire engine for a photograph. From left to right are Bill Jarboe, his uncle Steve, brother Jim, father A.J., brother Ted, brother Bob, and little brother John. After merging under city control, many Takoma firefighters like the Jarboes received pay as firemen but returned to the station as volunteers when off duty. (Courtesy of the Jarboe family.)

Six

A COMMUNITY CONFRONTS CHANGE

1960–1980

By the late 1950s, a series of challenges galvanized citizens on both side sides of the boundary line to come together around common goals.

On the District side, rapidly changing demographics resulted from desegregation rulings and also the displacement of thousands of African Americans when the southwest quadrant of Washington was demolished for a freeway. White and black community members came together in 1958 as Neighbors, Inc., committed to sustaining integrated middle-class neighborhoods in the face of white flight.

Then, in the mid-1960s, the Maryland Highway Department proposed cutting the 10-lane North Central Freeway through Takoma Park and Northwest DC, connecting the Capital Beltway to downtown Washington. Both sides of Takoma Park joined with the other threatened neighborhoods to defeat the proposal. Four years of organized resistance, led by Sam Abbott, resulted in highway funds being redirected to build the Metro system instead.

Metro construction brought its own threats to the character of the residential neighborhood, and Montgomery College added to the pressure in 1973 when it announced plans to raze 21 homes in order to expand its campus. Takoma Park residents rallied again and waged an eight-year battle to preserve their community. Although a number of significant historic buildings were in fact demolished, the crisis led to the creation of National Register historic districts on both sides of the District of Columbia–Maryland boundary line.

Meanwhile, high-rise public housing was changing the streetscape along lower Maple Avenue, as well as along New Hampshire Avenue at the outer edge of the city, creating more space for new residents.

As the 1970s came to a close, the old train station and many elegant Victorian houses were gone, but much remained, including the city's trolley-era shopping corridor, Gothic churches, and tree-lined residential streets. New organizations like Plan Takoma (founded in 1973) and Historic Takoma (1978) were ready to respond to future challenges.

In the face of rapidly changing demographics, activists in Takoma, DC; Shepherd Park; Manor Park; and Brightwood formed Neighbors, Inc. in 1958. They worked to foster an interracial and economically diverse urban community by fighting discriminatory real estate practices and building strong community bonds. Takoma resident Loretta Neumann (first row, second from left) served as president of the 1981 Neighbors, Inc., board shown here, which helped launch Plan Takoma to push for economic revival and preservation of the neighborhood. (Courtesy of Neighbors, Inc.)

"...man's satisfaction in belonging to a community where he can find security and significance..."

Pres. Lyndon B. Johnson
State of the Union Message

The cover of the Neighbors, Inc. 1964 annual report reflects its vision of a fully integrated community. (Courtesy of DC Public Library, DC Neighborhoods Collection, Washingtoniana Division.)

This brochure from the early 1960s reflects Neighbors, Inc.'s commitment to building a lively, middle-class, interracial neighborhood. Note the neighborhoods that were the focus of this effort, with Coolidge High School, the swimming pool at Takoma Recreation Center, and the Takoma Park branch of the DC Public Library listed as special amenities. (Courtesy of the DC Public Library, DC Neighborhoods Collection, Washingtoniana Division.)

Following desegregation, Coolidge High School went from all white to predominantly African American and lower income. As a sophomore in 1962, Henry Kennedy (first row, left) was the only black athlete on the tennis team. By his graduation in 1964, three whites remained on the team. Kennedy, now a US District Superior Court justice, is part of the alumni association, which since 2005 has greatly expanded its efforts to reenergize the school through afterschool and summer programs. (Courtesy of Coolidge High School.)

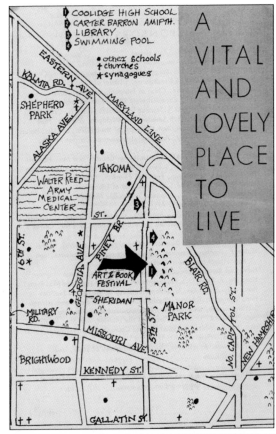

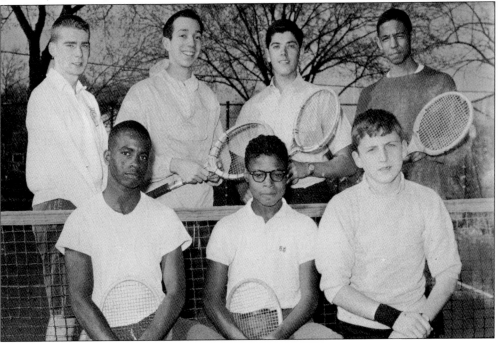

Experimental blues-folk guitarist John Fahey grew up on New York Avenue, bought his first guitar from Sears Roebuck at age 12, and made his first recordings in 1959 at age 20. Issued on his own label, Takoma Records, he sold the records himself from the gas station where he worked. Fahey credited Dick Spottswood with introducing him to early blues recordings. His second and most enduring label design (left) pays homage to the 78-rpm records that inspired Fahey and other artists that the Takoma label brought to national attention, such as Leo Kottke. Fahey's 1963 release (below), recorded after he moved to Los Angeles, brought him national attention that continues today. Fahey maintained Takoma Records for 20 years before selling it to Chrysalis Records. Fahey died in 2001. (Both, courtesy of Joe's Record Paradise.)

The crossroads of New Hampshire Avenue and University Boulevard is half in Takoma Park and half in Langley Park. Starting in 1945, the 450-acre McCormick-Goodhall family estate had been transformed by an explosion of apartment buildings that attracted successive waves of immigrants, war veterans, and middle Europeans and, beginning in 1970, people from Africa, the West Indies and especially Latin America. Four shopping centers soon sprouted up at the crossroads. The last of these, Hampshire Langley Center, opened on the northwest corner inside the Takoma Park city limits in 1961, anchored by a Safeway grocery. In 1987, business owner Erwin Mack founded the Takoma Langley Crossroads Development Association (CDA) to address the concerns of the business community in this multi-jurisdictional international corridor. Among CDA's successes are a day laborer site; numerous streetscape and pedestrian safety improvements; standards for property maintenance; and enhanced mass transit. (Courtesy of Historic Takoma.)

To help meet the increasing demand for low-income rental housing, Montgomery County partnered with the city in the early 1960s to build the first public housing high-rises in the county along Maple Avenue. The 10-story Winchester Apartments opened in 1962, followed by the Park Ritchie Apartments, which replaced a number of small houses in the largely African American neighborhood between Maple and Oswego Avenues. (Courtesy of Historic Takoma, photograph by Paul McKnight.)

With the construction of the high-rises, Ritchie Avenue and lower Maple Avenue between the city hall and Sligo Creek were finally paved. The heart of the African American community, it was the last area of the city to receive attention. (Courtesy of the Powell family.)

Alberta Dawes (center) stands outside Takoma Park Baptist Church with her daughters Thelma A. Smith (left) and Katherine Lewis (right). Alberta and Adolph Dawes moved to Takoma Park in 1924 from rural Culpeper, Virginia, to join family members who had arrived years before. After raising their six children on Lincoln Avenue and then Oswego Avenue, they sold their property in 1964 to the developers who built the Park Ritchie high-rise. They bought a house on Piney Branch Road that is still in the family. (Courtesy of the Dawes family.)

For many years, Alberta Dawes's son Roland ran a successful trash business. He later opened a barbershop on Carroll Avenue and was a Takoma Park councilman in the 1980s. His granddaughter Dominque was the first African American to earn an Olympic medal in gymnastics. (Courtesy of *Takoma Voice*, photograph by Julie Wiatt.)

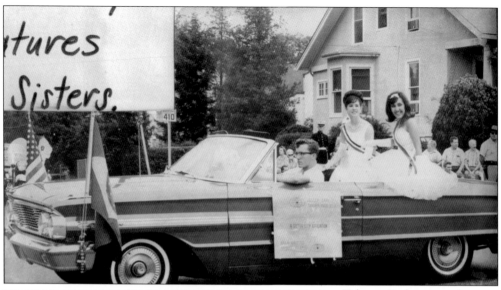

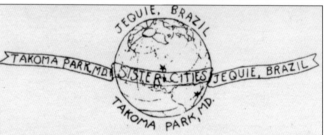

Put Your Pennies Towards Peace, Goodwill & Understanding

SHOPPERS STOP!
SATURDAY 10 AM - 2 PM
TAKOMA PARK
SISTER CITY THRIFT SHOP
FANTASTIC
values of fine outgrown clothing
for men-women-children
Men's suits $2 to $8 -- good selection
. . .ALL SIZES. . .
HAND-PICKED
BARGAINS on children's play clothes, shoes
(50¢) coats dresses, evening wear, suits, drapes,
household items . .
*Sponsored by Takoma Park-Jequie, Brazil
Sister City Committee*
Shop supports student exchange program and must
have more support if a formal exchange is made in the
next 30-60 days
(A People-to-People Program)
7054 Carroll Avenue (Daly's Cleaners)
CLOTHING CONTRIBUTIONS. . .CALL JU 8-8860

Takoma Park ventured into international relations in 1963 when it created a partnership with Jequie, Brazil, as part of the federally endorsed Sister Cities program. Over the next 10 years, city officials traded visits, students from the two cities exchanged places for the school year, and the two cities celebrated each other's culture. The first student ambassador from Jequie, Arly Bourie, is shown here in the 1963 Fourth of July Parade with Leslie Zark (left), who would soon head for Brazil. The park in North Takoma was the site of a Brazilian festival in 1965, and soon after, it was renamed Jequie Park. Although there was strong city support, most of the work and fundraising was done by volunteers. From 1963 to 1970, the Sister City Thrift Shop at Takoma Junction provided the majority of the funds used to assist the exchange students. (Both, courtesy of Historic Takoma.)

This Stick-style double house at the corner of Tulip and Maple Avenues was built by Byron and Seth Ford of Utah in 1885. Like many other large older houses, it was converted to multifamily use and by the early 1960s had fallen into disrepair, above. In 1965, landlord Sterling Bockoven won a Save Takoma Park award for rehabilitation and restoration of the house. Since 1987, owners Caroline and Tom Alderson have hosted a literary "theatrical" at the house each Halloween. (Both, courtesy of Caroline Alderson.)

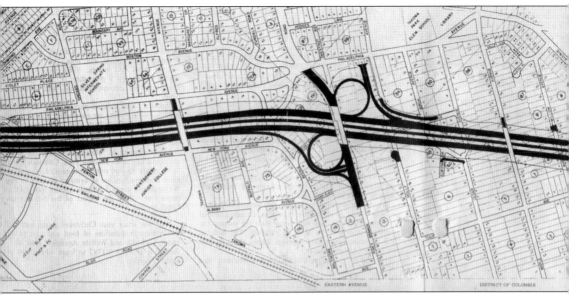

Little could have prepared the community for the intensity of the North Central Freeway fight. This map shows one proposed route for the 10-lane freeway that would have split Takoma Park in

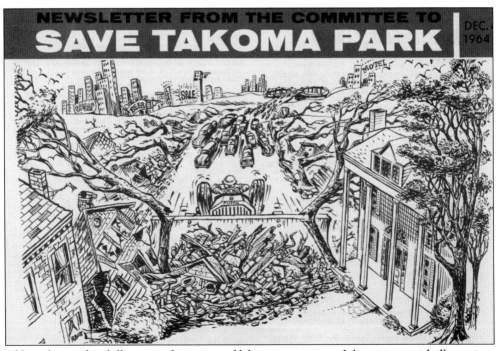

Abbott drew on his skills as a graphic artist and labor organizer to mobilize citizens with illustrations like the newsletter cartoon above. (Courtesy of the Abbott Collection, Historic Takoma.)

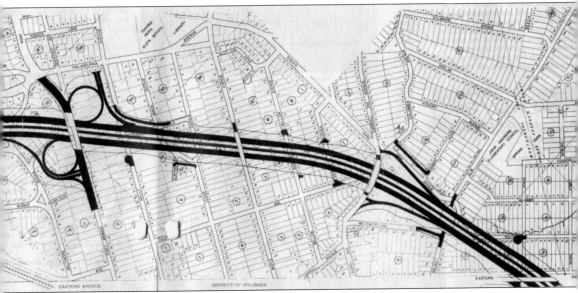

two. Alerted by a neighbor's telephone call in July 1964, Sam Abbott rounded up enough protestors to keep the public hearing going for two days. (Courtesy of the Takoma Park, MD, Library.)

Abbott's strategy was to unite with predominantly black neighborhoods to the south that were likewise slated for displacement. His slogan, "No White Man's Roads through Black Man's Lands," captured the sentiment of the neighborhoods that were to be sacrificed. Four years of hard work paid off, and the state finally backed down in favor of investing in mass transit. (Courtesy of the Abbott Collection, Historic Takoma.)

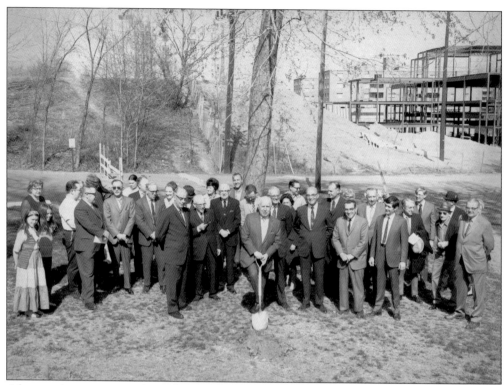

After nearly a century with no dedicated city hall, Mayor William Miller succeeded in getting one built. The ground-breaking in 1971 shows the adjacent Piney Branch Elementary School under construction. Sadly, Miller died just weeks before moving into the mayor's office in the new building, which is shown below with the adjoining library. In 2005, an addition to the building's front facade greatly altered its appearance. (Both, courtesy of Historic Takoma.)

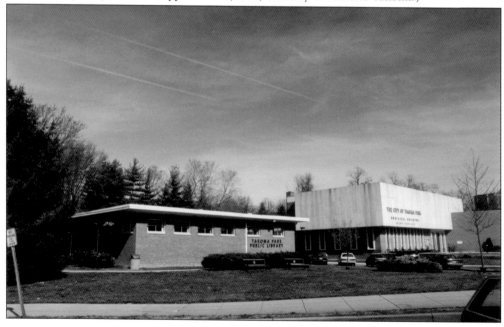

In 1971, the community learned of a plan to rezone eight of the oldest blocks north of the proposed Metro station for high-density multifamily and commercial development, as illustrated in this map. Printed on yellow paper, it became known as the "Mustard Sheet." (Courtesy of Historic Takoma.)

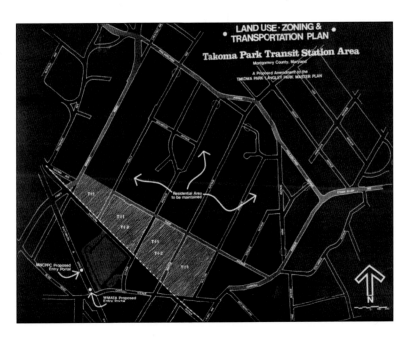

BE YE INFORMED — ALL CITIZENS OF TAKOMA PARK, HOMEOWNERS & RENTERS, YOUNG & OLD, ONE & ALL —

The Mayor & City Council have announced a one-year study leading to the establishment of a

MASTER PLAN FOR TAKOMA PARK.

The initial PUBLICK BRIEFING will be held WEDNESDAY, APRIL 9th, 1975, 7:30 pm at the MUNICIPAL BUILDING, 7500 Maple Avenue.

Like the embattled patriots of 1776, we, too, have suffered a long string of abuses. For over a decade the Tories of today have inflicted one indignity after another upon the citizens of Takoma Park: the ill-fated North Central Freeway which would have blasted right through our community; the arrogant seizure & destruction of historic Block 69 homes for Montgomery College expansion; the closing of Silver Spring Intermediate School & the proposed shutting down of Takoma Park Elementary School; the pernicious actions of absentee landlords & speculators; the notorious "Mustard" Metro Station Impact Plan which would have widened streets, levelled our trees, flattened our land, & bulldozed six blocks of homes for the construction of high-rises & commercial buildings. After 3½ years of struggle led by the Save Takoma Park Committee, the citizens have just won the approval of the Montgomery County Council for preserving the residential character of the areas around the Transit Station thru down-zoning & the other citizen proposals. Having just won this fight, must we again battle to save our community and homes?

We do not know the purpose of this proposed new Master plan. All we do know, based upon the lessons of the past ten years, is that we will have to celebrate the Nation's Bicentennial by renewed dedication to this guiding principle of our Revolutionary Forefathers:

ETERNAL VIGILANCE IS THE PRICE OF LIBERTY!

Issued as a public service by the SAVE TAKOMA PARK COMMITTEE, Mrs. Dorothy M. Porter, President. Telephone 270-5524.

To galvanize opposition, Sam Abbott designed a poster using Paul Revere to sound the alarm over the proposed plan to alter the residential character of the area. Three years of concerted opposition, led by the Save Takoma Park Committee, forced cancellation of the plan. Meanwhile, speculators were able to demolish Victorians on the District side of Eastern Avenue adjacent to the Metro to build garden apartments. (Courtesy of the Abbott Collection, Historic Takoma.)

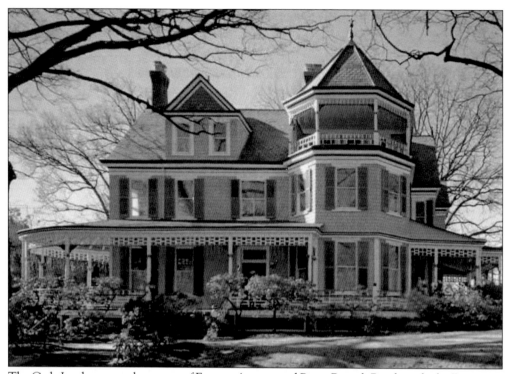

The Cady-Lee house on the corner of Eastern Avenue and Piney Branch Road inside the District—now known as the Cady-Lee Mansion—was the grandest of Takoma Park's Queen Anne Victorians. To save it from demolition in 1983, activists employed a new strategy by securing its designation on the National Register of Historic Places and District list of protected historical sites. (Courtesy of Historic Takoma.)

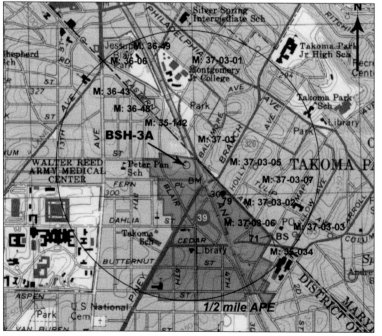

Plan Takoma worked to establish a historic district to protect all homes in the oldest section of the District neighborhood. Its success encouraged the creation of a comparable historic district on the Maryland side. Sadly, it was too late to save the old train station (lost to arson in 1967) or General Carroll's manor house (burned in 1960 as a fire department training exercise). (Courtesy of Historic Takoma.)

Montgomery College's 1970s expansion plans threatened to level the entire block of houses in North Takoma known as Block 69 (as designated on the original subdivision plat map), which included some of the city's finest Victorian houses. The college began systematically buying them, house by house, for demolition. On the morning of September 24, 1972, Etta Mae Davis confronted the bulldozers attempting to raze the Van Houten house next door at 605 New York Avenue. During the standoff that ensued, the supervisor, shown here, offered Davis a glass of water. Several people were arrested, but over the next year, a compromise allowed all but four houses to remain. To ensure future protection, Maryland activists secured historic district status like their DC neighbors. (Both, courtesy of the DC Public Library, Star Collection, © *Washington Post*.)

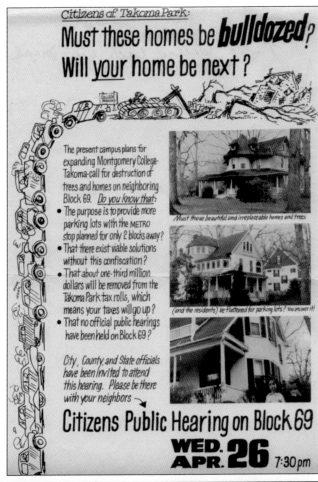

Citizens of Takoma Park:

Must these homes be **bulldozed?**
Will <u>your</u> home be next?

The present campus plans for expanding Montgomery College-Takoma-call for destruction of trees and homes on neighboring Block 69. *Do you know that*:

- The purpose is to provide more parking lots with the METRO stop planned for only 2 blocks away?
- That there exist viable solutions without this confiscation?
- That about one-third million dollars will be removed from the Takoma Park tax rolls, which means your taxes will go up?
- That no official public hearings have been held on Block 69?

Must these beautiful and irreplaceable homes and trees

(and the residents) be flattened for parking lots? You answer it!

City, County, and State officials have been invited to attend this hearing. Please be there with your neighbors →

Citizens Public Hearing on Block 69
WED. APR. **26** 7:30 pm

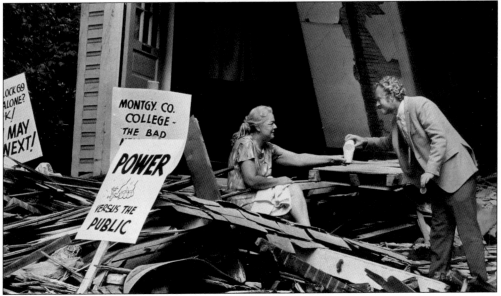

As new subdivisions drew residents away from the District and adjoining older suburbs, students at the nearby University of Maryland were discovering affordable and spacious options for group living in Takoma Park's aging Victorians and bungalows. Artists, musicians, activists, and others attracted by the city's character and affordability helped to forge a new cultural identity for Takoma Park. In the late 1960s, David Eisner opened Maggie's Farm (left), a small boutique catering to counter culture tastes, at the corner of Carroll and Columbia Avenues. Two blocks north, Michael Willis ran another counter culture shop selling T shirts, like the ones shown below, featuring sylvan suburban images expressing pride in Takoma Park's historic charm alongside youth-oriented R. Crumb–style imagery. The arrival of Joe's Record Paradise on Carroll Avenue near Westmoreland Avenue further established the community as a destination for local bohemians. (Left, courtesy of *Takoma Voice*; bottom, courtesy of Diane Falcone.)

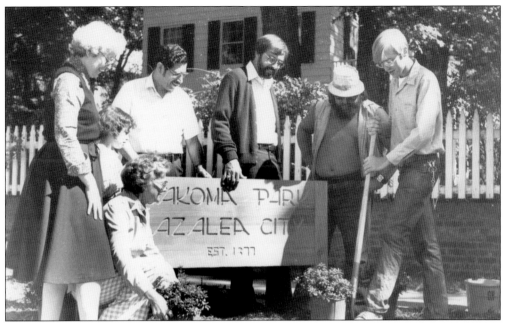

Local gardeners worked with the city in the 1970s to restore existing gardens and plant others in honor of those early residents whose own gardens had enriched and beautified the early suburb. In 1977, Takoma Park proclaimed itself "Azalea City." (Courtesy of Historic Takoma.)

The tragic death of a Takoma Park Elementary student inspired Katherine Paterson to write *Bridge to Terabithia*. When her fourth-grade son David lost his best friend Lisa Hill in a freak summer accident, she put pen to paper to make sense of it. Her novel received the Newberry Award of 1978. Seen above in 2007, mother and son returned to the school for a tree-planting ceremony honoring Lisa. (Courtesy of *Takoma Voice*, photograph by Julie Wiatt.)

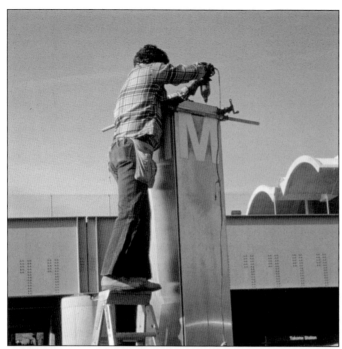

Running from Bethesda through downtown DC to Silver Spring, the Red Line opened in 1978. The Takoma station serves a higher percentage of pedestrians than any station outside of downtown Washington. Although Takoma Hall and several other storefronts along Cedar Street were lost, the community secured a green buffer at the edge of the Metro site, a space now threatened by plans for 90 townhouses. (Courtesy of photographer Robert Ginsberg.)

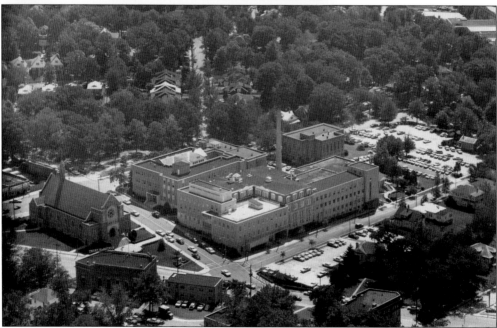

The buildings shown in this 1962 aerial view were occupied by the Seventh-day Adventists until the early 1980s. The departure of the general conference headquarters (left) in 1981 opened the way for Strayer University and Washington Theological Union. The Review and Herald moved to expanded quarters in Hagerstown in 1989, and its space now houses the artists of A.Salon and Washington National Opera, as well as a host of small nonprofits. The white-trimmed dormer windows of the two original structures can still be seen at the core of each building, though they are surrounded by later additions. (Courtesy of Review and Herald Publishing Association.)

Seven

Revitalizing a Legacy
1980–2010

The opening of the Metro in 1978 reestablished Takoma Park's commuter link to downtown and launched an era of new energy and growth as a new generation of young professionals moved in to fix up old houses and raise families.

In 1981, the city initiated a revitalization plan to improve the appearance of the Laurel and Carroll Avenues commercial corridor, while Plan Takoma undertook a similar effort to beautify the Fourth Street retail corridor in DC. Volunteers mobilized to preserve the historic outbuildings and grounds of the 1884 Thomas-Seigler property as a city park and expand protection of the city's historical neighborhoods, creating Montgomery County's largest historic district in 1992.

Three-term mayor Sam Abbott spearheaded a successful campaign to retain Takoma Park's junior high school and established Takoma Park as a nuclear-free zone and a sanctuary for Central American refugees. The city launched the first recycling program in Montgomery County.

The early 1980s saw the beginnings of the Takoma Park Folk Festival, the fall Takoma Park Street Festival, and Sunday Farmers Market. Then as now, resident musicians, artists, and writers enlivened the social life of the community with house concerts, open studios, and readings at the library.

At the same time, rising real estate values led to the gradual displacement of the elderly working class and other residents of modest means. In the early 1980s, the city established rent control to promote affordable housing for apartment dwellers, and in a number of cases, tenants have been able to convert buildings from rental to owner-occupied condominiums.

In 1997, citizens voted to end the city's cumbersome county jurisdictional divide, and Takoma Park neighborhoods in both Montgomery and Prince George's Counties were unified within Montgomery County.

As of the 2000 census, the city of Takoma Park had 17,229 residents, diverse in age, ethnicity, language and socioeconomic levels—in part a reflection of demographic change all over metropolitan Washington. Commitment to a culturally diverse population remains strong, as children attend school with classmates from scores of countries and churchgoers learn traditional hymns in multiple languages. Residents lining the streets for the 2010 Independence Day Parade cheered marchers and performers from the Veterans of Foreign Wars, Takoma Park Post No. 350, and the Trinidad and Tobago Steel Band to the Sherman Avenue Precision Grill Team and the Freedom Alliance.

As mayor from 1980 to 1985, Sam Abbott leveraged the creative energy of activists, musicians, and artists to create traditions like the Takoma Park Folk and Street Festivals, reinvigorating the community and its sense of identity. In addition to local issues, his administration took on a larger political agenda, banning business with nuclear manufacturers, welcoming refugees, and denouncing US war policy. (Courtesy of the Abbott Collection, Historic Takoma.)

Abbott lost his third reelection effort in 1986 by eight votes. In this photograph, he shows off his chops with local string band Hambone Sweets (from left to right, John O'Laughlin, Karen Collins, Fred Feinstein, Sid Netherby, and Pete McClurkin). Sam Abbott remained active in local politics until his death in 1990. (Courtesy of Karen Collins.)

The popular Takoma Park Street Festival began in 1981 as a Victorian festival to boost local commerce. Staged every year since, it has become a regional tradition. Local musicians are featured, and the cuisine of the food vendors runs the ethnic gamut. The original 40 tents for crafters and vendors has expanded to 200, stretching along Carroll Avenue from Eastern to Columbia Avenues. Early organizers included Jude Garrett (of Now and Then) and Jan Schwartz (of Finewares, now closed). Andrea Stevenson (Urciolo) took over as coordinator until 2004, when the festival became a project of Old Takoma Business Association, an alliance of local businesses from the Takoma Theatre on Fourth Street to Takoma Junction. (Right, courtesy of Historic Takoma; below, courtesy of *Takoma Voice*, photograph by Eric Bond.)

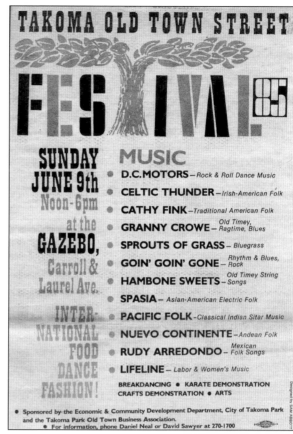

TAKOMA OLD TOWN STREET

FESTIVAL 85

SUNDAY JUNE 9th
Noon–6pm
at the
GAZEBO,
Carroll &
Laurel Ave.

INTER-NATIONAL FOOD DANCE FASHION!

MUSIC

- **D.C. MOTORS** — *Rock & Roll Dance Music*
- **CELTIC THUNDER** — *Irish-American Folk*
- **CATHY FINK** — *Traditional American Folk*
- **GRANNY CROWE** — *Old Timey, Ragtime, Blues*
- **SPROUTS OF GRASS** — *Bluegrass*
- **GOIN' GOIN' GONE** — *Rhythm & Blues, Rock*
- **HAMBONE SWEETS** — *Old Timey String Songs*
- **SPASIA** — *Asian-American Electric Folk*
- **PACIFIC FOLK** — *Classical Indian Sitar Music*
- **NUEVO CONTINENTE** — *Andean Folk*
- **RUDY ARREDONDO** — *Mexican Folk Songs*
- **LIFELINE** — *Labor & Women's Music*

BREAKDANCING • KARATE DEMONSTRATION
CRAFTS DEMONSTRATION • ARTS

Designed by SAM ABBOTT

● Sponsored by the Economic & Community Development Department, City of Takoma Park and the Takoma Park Old Town Business Association.
● For information, phone Daniel Neal or David Sawyer at 270-1700

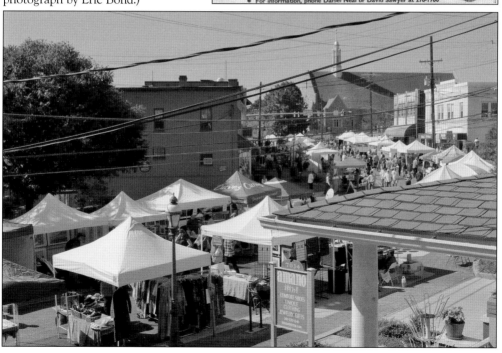

The idea for the Takoma Park Folk Festival was born in Sam and Ruth Abbott's living room, where activists and musicians gathered in the 1970s to swap civil rights, peace, and farm workers' songs. Saul Schniderman, David Sawyer, Sara Green, Richard Holzsager, Loretta Neumann, Paul Plant, and Larry and Lenore Robinson joined Sam Abbott to organize the first festival in 1979, envisioned to bring the two communities—DC and Maryland—together to raise money to save the Takoma Theater from the hands of a developer. In later years, the festival benefited the Takoma Park Boys and Girls Club, then a broad range of community groups. Then as now, musicians played for free. In 1980, the program included blues singer Eleanor Ellis, Double Decker String Band, Magpie, Rudi Arrendondo, Andean players Rumisonko, Folkworks, jazz singer Dorothy Williams, Continental Drift, Gene Ashton, Celtic Thunder, and Fabrangen Fiddlers. (Both, courtesy of Takoma Park Folk Festival.)

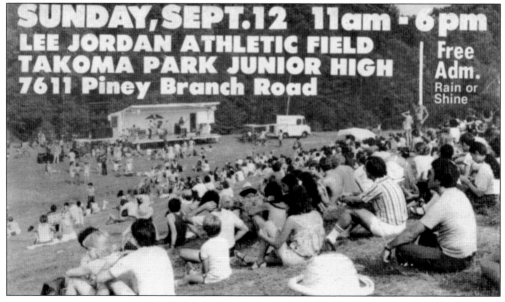

Since joining Takoma Park's vibrant traditional music scene in the 1980s, Cathy Fink (left) and Marcy Marxer have enriched the larger community in numerous ways—as performers in the Takoma Park Folk Festival and many venues, as artists in the schools, producing recordings for other musicians, mentoring younger musicians, founding a banjo festival, even teaching ukulele to retirees and, since 1986, presenting an annual holiday concert featuring national treasures like Pete Seeger and Ella Jenkins. Fink and Marxer have won two Grammys for albums for children and families. (Courtesy of Community Music, Inc.)

A hotbed for traditional music in the 1980s, Takoma Park was also home to contra dances that drew enthusiasts from across the DC metropolitan area, like this one held in the fellowship hall of Takoma Park Presbyterian Church in 1983. The early folk festivals included a dance stage, a tradition that continues today. (Courtesy of Susan Schreiber.)

A Salute to Lee A. Jordan

In Appreciation and Commendation for the Skill, Integrity & Devotion which have characterized your contributions to the Youth of this community...

Be it known that on this day we hereby dedicate the

Lee A. Jordan Athletic Field

so that your deeds will continue to light the paths that others follow.

6 June 1981 Takoma Park, Md.

DAVID ROBBINS, Director
Montgomery County Department of Recreation

BELLE ZIEGLER, Director
Takoma Park Recreation Department

OTIS J. MATTHEWS, Vice President
Takoma Park Boys & Girls Club

ROBERT ENGLE, President
Montgomery County Baseball Association

STANTON G. ERNST, Director of Parks
Maryland National Capital Park & Planning

EDWARD W. HUTMIRE, President
Takoma Park Recreation Council

GEORGE B. BAILEY, Chairman
Area IV Recreation Advisory Board

EDWARD ANDREWS, Superintendent
Montgomery County Public Schools

CHARLES W. GILCHRIST, Executive
Montgomery County Government

SAM A. ABBOTT, Mayor
City of Takoma Park, Maryland

On June 8, 1981, parents and kids alike gathered to pay tribute to Lee Jordan by naming the playing field adjacent to the junior high school in his honor. After nearly 50 years of coaching and mentoring, much of it on the same field, it was "Mr. Lee's" turn to be showered with praise for inspiring a community. Several major-league athletes who first played for him offered their appreciation. Among many tributes were fond words from actress Goldie Hawn, a local girl who made good. In 2003, Lee Jordan was inducted into the Montgomery County Civil Rights Hall of Fame for his role in easing the way for the peaceful integration of schools in Takoma Park. (Both, courtesy of the Jordan family.)

Lee,
You are my sunshine!
Love
Goldie Hawn

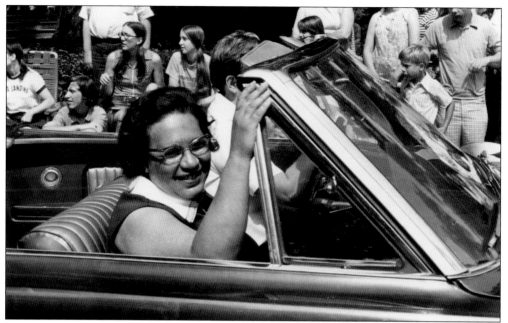

Belle Ziegler served as the city's first recreation director from 1964 until 1984, mobilizing city staff and volunteers alike. A tireless volunteer herself, she came to be the heart and soul of the Independence Day festivities. In a rare moment in the limelight, she is seen here as the parade's grand marshal. In 2010, Jequie Park on Takoma and Albany Avenues was renamed in her honor. (Courtesy of the Ziegler family.)

One of Belle's neighbors on Sherman Avenue was Opal Daniels. Shown here with her husband, Henry, Opal became a key member of Belle's volunteer corps, giving her time to the city's annual Easter, Fourth of July, and Halloween celebrations, as well as serving 40 years as a Girl Scout leader. Appointed to the county's parks board, she spent 25 years battling developers' plans to put townhouses in the open land behind her house. In 1988, the space (off Hancock Avenue) officially became Opal Daniels Park. (Courtesy of Daniels family.)

Founded in 1949, Spring Knolls Cooperative Nursery School was for many years located at Takoma Park Baptist Church on Piney Branch Road, serving District and Maryland families. This 1987 photograph shows the three- and four-year-old class with teacher Ricky Green. At both Spring Knolls, which moved to Silver Spring in the 1990s, and Takoma Park Cooperative Nursery School, community ties are strengthened by parents working together to run the school and assisting teachers in their children's classrooms. (Courtesy of Lois Chalmers, photograph by Elias Vlanton.)

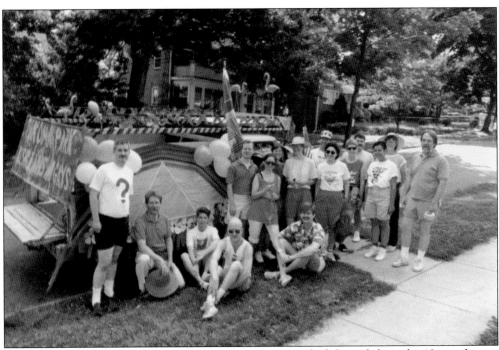

In 1988, an ad in the *Washington Blade* announcing a potluck brunch brought 40 people to a small apartment on Greenwood Avenue. Takoma Park Lesbians and Gays (TPLAG) has met every month since. Hosted by different members, the brunch brings together a cross section of Takoma Park, such as writers, attorneys, teachers, government employees, and many involved in community activities across the city. TPLAG members pose here with their float just before the 1993 Fourth of July Parade. (Courtesy of Bruce Williams.)

The year 1983 marked the centennial of B.F. Gilbert's founding of Takoma Park. Longtime residents Ellen Marsh and Mary Anne O'Boyle documented the suburb's first 100 years in *Takoma Park: Portrait of a Victorian Suburb 1883–1983*. Showcasing images drawn from the archives of the Takoma Park Historical Society, which had formed in 1916, the book was published by Historic Takoma, Inc., which assumed ownership of the archives in the early 1980s. (Courtesy of Historic Takoma.)

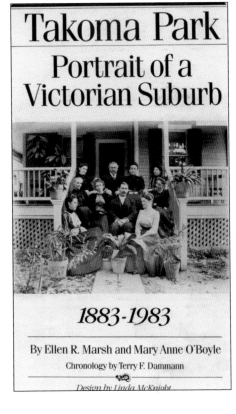

Takoma Park
Portrait of a Victorian Suburb

1883-1983

By Ellen R. Marsh and Mary Anne O'Boyle

Chronology by Terry F. Dammann

Design by Linda McKnight

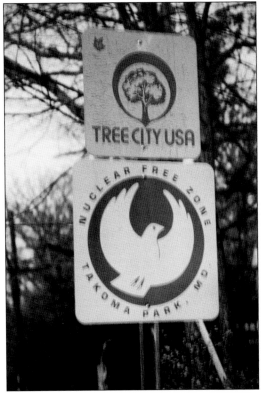

Also during the centennial year, Takoma Park declared itself a nuclear-free zone, one of the earliest US cities to do so. The ordinance banned the city from purchasing any item produced by a manufacturer involved in the nuclear industry, which included vendors like Westinghouse and General Electric. With a few modifications, Takoma Park remains nuclear-free in 2010. (Courtesy of Diana Kohn.)

C.A.S.A. NEWS

VOLUME I - ISSUE I DECEMBER 1985

MORE THAN A HOUSE

The "CASA" at 310 Tulip Avenue is not a living quarters, as the word house suggests; rather, it represents the shelter and security of such a structure. Since its beginning, less than a year ago, CASA has become the symbol of a community responding to refugees of war-torn Central America.

What do CASA and community support mean to refugees on an everyday basis? Roberto, an El Salvadoran now living in Langely Park, typifies individuals coming to CASA. Roberto was interrogated and tortured by the Salvadoran military before fleeing his homeland. His crime: distributing food and medicine to refugees inside El Salvador with Archbishop Oscar Romero.

Roberto said that he could not ignore the injustices waged against the poor in his country. "My parents were good Christians," he said. "They gave me the spirit to help others."

An article in the Montgomery County Sentinel, "The Two Faces of Freedom," Jan. 9, contrasted Roberto's current situation to that of a Russian refugee living here. Before fleeing the United States, their lives showed striking similarities, but, once here, have differed vastly. The Russian was one of 611 persons granted asylum in 1985; whereas, Roberto was one of thousands of El Salvadorans denied refuge. (In 1985, 2,299 El Salvadorans requested political asylum. Only 74 received it.)

The Immigration and Naturalization Service's interpretation of the 1980 Refugee Act has left Roberto — and thousands of other Central Americans — pressed to sur-

(con't. on back)

REFUGEE LEGISLATION

Needing your support, is legislation which could make the lives of Salvadoran refugees less insecure. The Moakley/Deconcini Bill would suspend deportation of Salvadorans from the United States for about two years. The suspension would allow time for a study of security and humanitarian problems of Salvadorans threatened with deportation and of general conditions of Salvadoran refugees and displaced persons in Central America.

Senator Charles Mathias (R-MD), still undecided on this legislation, is a key vote. Call him at 224-4654, and tell him to vote yes for S.377.

To stay up-to-date, call Central American Legislative Hotline, 543-0665.

C.A.S.A. NEWS is published six times a year by C.A.S.A. of Maryland, Central American Solidarity & Assistance, 310 Tulip Avenue, Takoma Park, MD 20912. (301) 270-0442.

Director: Nilsa Marin
Editor: Rebecca Wolf

Chairperson: Betty Hoover
Board of Directors: Nancy Atkinson, Sharon Cargo, Deb Ferrera, Jorge Granados, Linda Kravitz, Mary Ann Larkin, John Smallwood, George Taylor.

In the early 1980s, refugees of civil unrest in Latin America began moving into Takoma Park. Community members established a sister city partnership with the war-ravaged village of Santa Marta in Guatemala. In 1984, local churches helped form the Central American Sanctuary Association (CASA) to provide emergency and immigration assistance as well as English instruction to new immigrant arrivals. The first CASA newsletter appeared in December 1985, about the time Takoma Park declared itself a sanctuary city. (Courtesy of CASA de Maryland.)

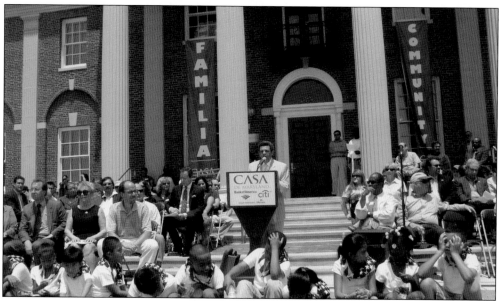

CASA de Maryland has become the preeminent immigrant-advocate organization in the state, with additional offices in Silver Spring, Baltimore, and Wheaton. In 2010, director Gustavo Torres (at the podium) and CASA de Maryland were lauded by local and national leaders at the grand opening of a multimillion-dollar new headquarters in the restored McCormick-Goodhall mansion just outside the Takoma border in Langley Park. (Courtesy of *Takoma Voice*, photograph by Julie Wiatt.)

Following in the footsteps of Lee Jordan, a new generation of volunteers expanded the sports leagues. Tony Langley took over the Boys and Girls Club, while Gary Weinstein and Ed Wilhelm focused on baseball. Wilhelm also became the driving force behind Takoma Park Neighborhood Youth Soccer. Seen here refereeing a game, barefoot as usual, he is standing on the field behind Piney Branch Elementary School named in his honor in 1995. (Courtesy of *Takoma Voice*, photograph by Julie Wiatt.)

As the population of Takoma Park became more diverse and sports brought families of all ethnic and racial backgrounds together on the playing field, soccer gained prominence. Wilhelm helped found the Takoma Park soccer league in 1980 in part to include the youth of Takoma, DC, who weren't eligible to participate in the official Maryland leagues. The program, run entirely by volunteers, serves boys and girls pre-kindergarten through high school. (Courtesy of *Takoma Voice*, photograph by Eric Bond.)

The Sunday Farmers Market at Laurel and Carroll Avenues opened in 1983, one of the first in the area to sell only locally grown produce. *Washington Post* agricultural writer Ward Sinclair was so impressed by farmers like Roland Burland that he retired from the *Post* to take up farming and join the market. Since 1990, the market has operated year-round. In 2008, a second market opened on Wednesdays at Takoma-Langley Crossroads. (Courtesy of *Takoma Voice*, photograph by Julie Wiatt.)

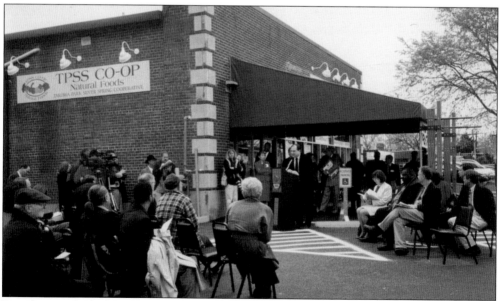

Few places embody the city's alternative populist philosophy better than the Takoma Park–Silver Spring Co-op. Begun by neighborhood residents in 1981, the natural foods grocery operates democratically through the involvement of members, workers, and shoppers in decision making. This photograph marks the store's 1998 grand opening at Takoma Junction. A second store serves Silver Spring. After much heated debate, the co-op began selling meat products in 2007. (Courtesy of *Takoma Voice*, photograph by Julie Wiatt.)

When Mark Cho opened Mark's Kitchen at 7006 Carroll Avenue, he was continuing a tradition begun with the Electrik Maid in the 1950s. The Hishmeh brothers took over in the early 1970s before opening the Middle Eastern Market (now Middle Eastern Cuisine) next door in 1980. Mark, at right with his wife and son in 1990, followed, offering vegetarian and meat versions of Korean and American dishes. (Courtesy of *Takoma Voice*.)

Maggie's Farm owner David Eisner brought New York–based House of Musical Traditions (HMT) to Carroll Avenue in 1972 and after an eight-year hiatus in Berkeley Springs, West Virginia, reopened in Takoma Park in 1981. Offering instruments and recordings from around the globe, HMT's educational programs, monthly concert series, and participation in countless festivals as sound engineer have reinforced the community's identity as a musical and artistic stronghold. (Courtesy of *Takoma Voice*, photograph by Julie Wiatt.)

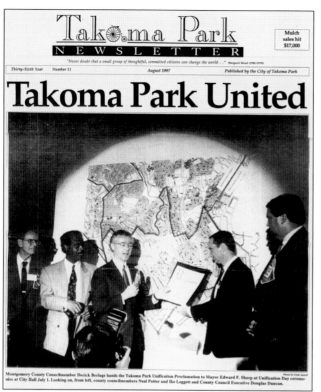

Thirty-Sixth Year Number 11 August 1997 Published by the City of Takoma Park

Takoma Park United

Montgomery County Councilmember Derick Berlage hands the Takoma Park Unification Proclamation to Mayor Edward F. Sharp at Unification Day ceremonies at City Hall July 1. Looking on, from left, county councilmembers Neal Potter and Ike Leggett and County Council Executive Douglas Duncan.

Not only did B.F. Gilbert's Takoma Park straddle the District of Columbia–Maryland boundary, it was also split between two counties, complicating city services and taxes for over 100 years. In 1980, Mayor Sam Abbott and city council members launched a new campaign to unify the Montgomery and Prince George's sections of the city. Years of intense lobbying followed. Finally, former mayor Steve DelGuidice used his leverage as a Prince George's County councilmember to convince his colleagues to allow a referendum vote. On July 1, 1997, Mayor Ed Sharp, flanked by politicians and activists, stood before a giant map and cut a ribbon tracing the Prince George's County line, officially marking the unification of the city. The *Takoma Voice* July 1997 issue celebrated the victory, and the entire city is now unified within the borders of Montgomery County. (Above, courtesy of Historic Takoma; right, courtesy of *Takoma Voice*.)

118

Featured on the editorial page of the *Takoma Voice* since 1988, local cartoonist Bill Brown uses humor to keep the baby boomer progressive image in check. This example was published in the wake of the unification victory. (Courtesy of *Takoma Voice*, by permission of William A. Brown.)

When Willliam "Doc" Fishbein closed Park Pharmacy in October 1998, the entire community mourned the passing of an era. First opened by W. Frederick Dudley in 1932, the store had been a cornerstone of the Carroll–Laurel Avenue downtown. Replaced by a corporate CVS Pharmacy two blocks away, Park Pharmacy remains a symbol of the demise of independent businesses in the face of large chain stores. (Courtesy of *Takoma Voice*, photograph by Eric Bond.)

Since 1997, the award-winning Lumina Studio Theatre has been providing local youth with a unique opportunity to perform Shakespeare and other classic works. As envisioned by directors David Minton and the late Jillian Raye, the training is rigorous and the productions imaginative. This performance of *Love's Labor's Lost* was staged at the Thomas-Siegler garden carriage house in 2000. (Courtesy of Lumina Studio Theatre.)

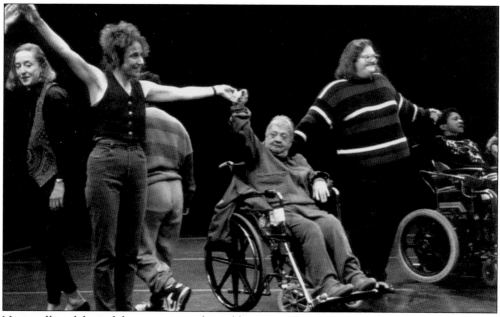

Nationally celebrated for innovative dance/theater works, Liz Lerman reaches out to include dancers of mixed ages and experience, even those in wheelchairs. She moved her Dance Exchange from downtown DC to Takoma Park in 1998. The Dance Exchange encourages community members to participate as dancers in the creation of works like *The Matter of Origins*. In 2002, Liz Lerman was honored with a MacArthur Fellowship (the genius grant). (Courtesy of Liz Lerman Dance Exchange.)

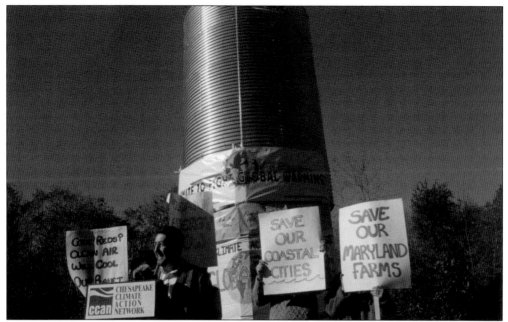

Mike Tidwell, a prominent author on climate change, has spearheaded local efforts to reduce reliance on fossil fuels. His 1915 bungalow on Willow Avenue, heated largely by solar power and a corn stove, may the closest thing to a zero-carbon home in the DC area. Following his example, several dozen households switched to corn, which is stored in the 25-foot-tall silo seen above, purchased by the city as part of the department of public works. (Courtesy of *Takoma Voice*, photograph by Julie Wiatt.)

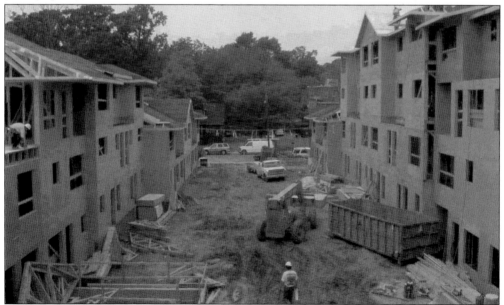

Takoma Village Cohousing opened two blocks from the metro stop in late 2000. One of the first such developments in the region, it includes 43 units. Prospective residents came together to design a multigenerational urban community that would foster mutual support and cooperation and encourage ecologically responsible living. (Courtesy of *Takoma Voice*, photograph by Julie Wiatt.)

Roscoe's crowing startled residents when he first appeared in town some time in the 1990s. Alan Doughterty on Carroll Avenue looked out for the rooster, as did Alma Thompson, who fed and sheltered the rooster behind the Mary Alan Apartments on Tulip Avenue (her children called him "Chick-chick"). Strutting around town like a citizen of the world, he came to be affectionately regarded as a symbol of Takoma Park's quirky and independent nature. Following Roscoe's demise, another neighbor, Joan Horn, led a campaign to raise funds to have local sculptor Normon Greene, shown here, memorialize the rooster in bronze. Roscoe's statue has kept watch downtown since 2002. (Courtesy of *Takoma Voice*, photograph by Julie Wiatt.)

Noting the unusual choice to erect a bronze statue in honor of a rooster, poet Merrill Leffler composed a eulogy in the classical style as part of the city's Spring for Poetry series. Leffler is editor of Dryad Press, a local independent literary publisher established in 1967. (Courtesy of Diana Kohn.)

Motorcat made her appearance in 1988, when the helmet-clad feline was first seen perched on the gas tank of her owner's Suzuki 500. The two rode together until Motorcat's death from natural causes in 1997, contributing to Takoma Park's image as a colorful and diverse community. (Courtesy of Getty Archives.)

Like Roscoe, Motorcat is now immortalized as part of a tile installation by John Hume at the Takoma Junction pavilion. (Courtesy of *Takoma Voice*, photograph by Julie Wiatt.)

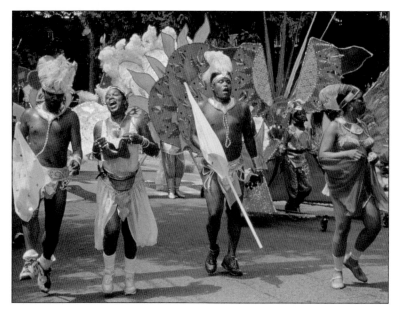

Some of the most popular performers at the Independence Day Parade are the festive Caribbean groups, whose elaborate costumes are as much a crowd pleaser as the music. (Courtesy of *Takoma Voice*, photograph by Eric Bond.)

The parade also brings out the quirkiness of Takoma Park residents. The Reel Brigade has put in an appearance for several years, encouraging their neighbors to forgo their gas-powered lawnmowers in exchange for the joys of human-powered push mowers. Several attempts to convince the city council to ban all but push mowers have failed to carry the day. (Courtesy of *Takoma Voice*, photograph by Julie Wiatt.)

The Takoma Park community welcomed a new wave of refugees in 1995, as Ethiopians, attracted by the political tolerance and available housing, began to arrive. Over the next decade, Amharic became the third most spoken language in the local schools after English and Spanish. The coffee ceremony shown here is one of many cultural traditions they have added to the city scene. (Courtesy of *Takoma Voice*, photograph by Tooky Bunnag.)

Our Lady of Sorrows Catholic Church at Larch and New Hampshire Avenues now serves a mostly Hispanic population. One of the traditions adopted into their service is the reenactment of the Stations of the Cross on Good Friday, which draws large crowds. (Courtesy of *Takoma Voice*, photograph by Eric Bond.)

In 2008, Alice Sims, Laurie Stepp, and Arturo Ho proposed a community art project—creating a mosaic for the outside of the city library. Young and old joined in, cutting tiles and learning the art of applying the tiny pieces to the wall facing Maple Avenue. The result offers a sparkling welcome to the community center complex. (Courtesy of *Takoma Voice*, photograph by Julie Wiatt.)

There is also a long tradition of public murals in the city. In 1982, Jim Colwell took on the drab pavilion at Takoma Junction, which was all that remained of the gas station that once housed the Sister City Thrift Shop. When he was done, four jazz musicians burst from the wall as *Guardians of the Neighborhood*. (Courtesy of Diana Kohn.)

Historic Takoma, Inc., gathered in 1999 at the Thomas-Siegler carriage house to celebrate the group's 20th anniversary. Past presidents pictured from left to right include Kathy Porter, Doug Harbit, Lorraine Pearsall, Ellen Marsh, and Karen Fishman (far right). City staffer Ted Kowaluk, second from right, oversaw renovations to the carriage house. (Courtesy of Historic Takoma.)

In 2004, Historic Takoma was able to use state and local grants to purchase 7328 Carroll Avenue as its permanent home. Originally built as a Piggly Wiggly grocery store during the 1930s, the building was home to Barcelona Nuts for nearly 40 years. Located in the Takoma Junction corridor, the renovated space will provide public access to Historic Takoma's extensive archives and contribute to the ongoing revitalization of the junction. (Courtesy of Historic Takoma.)

www.arcadiapublishing.com

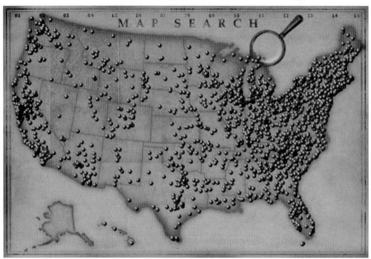

Discover books about the town where you grew up, the cities where your friends and families live, the town where your parents met, or even that retirement spot you've been dreaming about. Our Web site provides history lovers with exclusive deals, advanced notification about new titles, e-mail alerts of author events, and much more.

MADE IN THE USA

Arcadia Publishing, the leading local history publisher in the United States, is committed to making history accessible and meaningful through publishing books that celebrate and preserve the heritage of America's people and places. Consistent with our mission to preserve history on a local level, this book was printed in South Carolina on American-made paper and manufactured entirely in the United States.

This book carries the accredited Forest Stewardship Council (FSC) label and is printed on 100 percent FSC-certified paper. Products carrying the FSC label are independently certified to assure consumers that they come from forests that are managed to meet the social, economic, and ecological needs of present and future generations.

FSC
Mixed Sources
Product group from well-managed
forests and other controlled sources

Cert no. SW-COC-001530
www.fsc.org
© 1996 Forest Stewardship Council

Find Your Place in History.